HALF TITLE LEFT A detail from the richly embroidered flowing skirt of the sensational 1947 wedding dress of Her Royal Highness Princess Elizabeth is an example of the lavish craftsmanship for which the Hartnell workrooms were known.

HALF TITLE RIGHT The Hartnell label within the designer's creations was an intimate affirmation of status, in the same way logos and labels are today. The label reminded the wearer of her own relationship with the House of Hartnell, at a time when individual style mattered and the competition for clients was keen among all designers. Hartnell labels also appeared on royal clothing. This example on a 1927 wedding dress is from the days of the first salon, at 10 Bruton Street, Mayfair.

OPPOSITE An early evening dress of 1925 displays Hartnell's easy mastery of a complex design utilizing the most luxurious materials. The draped panels of the back are embroidered in leaf motifs, repeated at the hemline. The fine gauze of the wrap is weighted with ostrich feathers, which the designer would use into the 1960s.

RIGHT Hartnell, who remained stagestruck all his life, was still designing for the London theater in the 1970s. This early drawing, dated 1919 and entitled *Revue*, depicts a winsome soubrette typical of his early technique with its echoes of illustrators Leon Bakst, Aubrey Beardsley, and Alastair. It was probably produced for the Cambridge Footlights Revue of that year, the style recalling his program and costume designs for the revue *Folly*, or *The Bedder's Opera*.

OVERLEAF LEFT A detail of the back of a 1940s Hartnell black silk velvet evening coat shows the complex design of the colorful geometric embroidery arranged around the glass jewels, designed to dazzle during the grim wartime years of Utility.

MICHAEL PICK

BE DAZZLED!

NORMAN HARTNELL
SIXTY YEARS OF GLAMOUR AND FASHION

FOREWORD BY H.R.H. PRINCESS MICHAEL OF KENT

DESIGN: STAFFORD CLIFF
MANAGING EDITOR: JANE K. CREECH
EDITORS: DEBRA CASTELLANO AND ANNE HELLMAN WHITE
PRODUCTION: IAN HAMMOND AND DOMINICK J. SANTISE JR.
SPECIAL PHOTOGRAPHY: KULBIR THANDI

POINTED LEAF PRESS, LLC.

CONTENTS

During a Royal Tour of India in 1961, accompanied by His Royal Highness, Prince Philip, Duke of Edinburgh, and with the seventeenth-century Taj Mahal as a stupendous backdrop, Queen Elizabeth II is still a striking figure in a day ensemble by one of her favorite Dressmakers by Appointment.

Norman Hartnell was not just a man who created fashion. Possibly more important, he created glamour. When wearing his clothes, women looked and felt beautiful—sadly, no longer the objective, one senses, of designers today. To my mind, one of the most glamorous, elegant ladies in the Royal Family of modern times was my mother-in-law, Princess Marina, Duchess of Kent, who wore Hartnell from 1952—once Molyneux closed his doors—until her death in 1968. Cecil Beaton, who would have known, said Princess Marina was the most beautiful and elegant woman he had ever photographed—and her style owed much to Norman Hartnell's skill.

Princess Marina was not alone within the Royal Family to appreciate Hartnell. Most famously, he created the Coronation Dress in 1953 for Her Majesty Queen Elizabeth II, an iconic image of twentieth-century design. Hartnell dressed a number of other members of the British Royal Family, including the late Queen Mother and my sister-in-law, Princess Alexandra, both to stunning effect. This relationship with the ladies of the British Royal Family would last until his death in 1979.

Marie Christine

H.R.H. Princess Michael of Kent

OPPOSITE Her Royal Highness Princess Marina, Duchess of Kent (1906–1968) was photographed in 1956 for her fiftieth birthday by Cecil Beaton, in front of a portrait by Philip de László of her mother, Her Royal Highness Princess Nicholas of Greece, born Her Imperial Highness The Grand Duchess Elena Vladimirovna of Russia. Princess Marina was married in 1934 to Prince George, Duke of Kent (1902–1942), the third son of King George V and Queen Mary, wearing a dress by the Anglo-Irish Paris-based designer Edward Molyneux. An early fashion icon, she remained a client until the designer retired in 1952, but she also used Hartnell's skills. In the 1930s, Marina Blue, her favorite color, was popular internationally. This draped dress by Hartnell typifies her understated taste and style.

MICHAEL PICK

INTRODUCTION

Norman Bishop Hartnell, born on June 12, 1901, designed glamorous clothes for elegant women from the moment he began his business in 1923 until his death in 1979. For six decades his name and designs were considered sufficiently newsworthy to be continually seen in the international press, either associated with his clientele or with some strikingly original innovation. His early years were notable for his success in dressing high society and leading ladies of the stage and screen. His much-publicized achievements of the 1920s—creating innovative wedding dresses for famous brides of the period—led to greater fame, and during the four decades following the first royal wedding of 1935 and the Coronation of King George VI and Queen Elizabeth in 1937, he was the principal designer for the ladies of the British Royal Family. If he were remembered for nothing else, it would be for the Coronation dress worn by Her Majesty Queen Elizabeth II, now considered the most important dress of mid-twentieth-century design. By then he had been in business for thirty years, yet was only midway through a career that spanned decades of tumultuous changes and, given his clientele, reflected momentous occasions.

Yet Hartnell appeared untouched by the changes he witnessed, constantly updating his image with a continual flow of innovative designs. That Hartnell possessed a rare genius is self-evident. Few designers have the equal measure of talent, financial acumen, and luck to remain at the top in the mercurial world of fashion for so long and to make the improbable feat of remaining fashionable for six decades appear effortless. "He was the designer who made every woman look like a fairy queen," said his oldest client, Dame Barbara Cartland, the romantic novelist. His name became synonymous with ultra-luxurious fashion, and his merchandising arrangements after the late 1930s made the Hartnell name one of the first global designer brands.

The Hartnell success was the result of planning and consistent hard work allied to the designer's other talents. Hartnell set out to emulate the mid-nineteenth-century success of the British-born father of Parisian couture, Charles Frederick Worth, the Empress Eugénie's couturier, but in reverse—determining to make London the fashion center, rivaling or even superseding Paris. Hartnell was achieving his goal, boosted by royal patronage, when the outbreak of World War II necessarily curtailed dress design and the fashion industry was diverted to the war effort.

By 1930, Hartnell's success was made clear when the London *Daily Mail* hailed him as a man marked by an unparalleled rise to fame from obscurity. At the age of twenty-nine, he was compared to a meteor illuminating the postwar horizon of London, his salon acting as a mecca for the most beautiful and fashionable women. This rise to such glittering prominence was not achieved alone, nor was his subsequent success. He was astute enough to realize from the very beginning that in order to transform his designs into reality, he needed strong, capable people around him to deal with the minutiae of daily business. Behind the facade of the House of Hartnell there grew a structured series of workrooms employing competent workers, with the involvement of the designer's father, sister, and investors.

Born an Edwardian, Hartnell remained fundamentally Victorian all his life, practicing the work ethic of his parents which enabled their economic upward mobility. His appearance revealed his origins, for he was no willowy aesthete, but a stocky man with thick curly hair and a pink and white complexion, becoming florid as he aged. His widowed mother, Emma, brought a son and three daughters to her marriage to Hartnell's father, Henry. Both father and mother were hardworking Publicans who had progressed from the saloons of central London to the prophetically named Crown and Sceptre public house in the genteel suburb of Streatham, where Norman was born. Today, the owning or running of a smart public house would not seem unusual for the parents of a celebrity. But in the 1960s, attitudes were very different. There was a social stigma in being involved with what was considered a highly dubious trade, because of the clientele such a pub attracted. (Women who entered such a place were usually from a lower stratum of society—and if they were alone, they were obviously of the lowest.) Nevertheless, the income generated from the pub enabled the Hartnells to buy property, and they moved from suburban Streatham to Sussex. Their past was swiftly buried outside the family circle, becoming a secret never referred to in public, and Henry Hartnell became involved in the more acceptable wholesale wine and spirits trade.

Norman had a happy childhood, basking in the adoration of his elder stepsisters and brother, and especially in that of his older full sister Phyllis and his parents. He was fascinated with their clothes and later wrote: "My interest in fashion began with a box of crayons." Once he started drawing, he never stopped. "All of my school books on mathematics, geometry and algebra were covered with doodled designs of dresses and likenesses of the leading actresses of the day. . . . I had bought and studied so many picture postcards that I could draw them or their dresses from memory." Together with his love of music and singing, the solid and sensible Victorian values of his parents ensured that he became popular on entering Mill Hill School in North London, a nonconformist private boarding school (known in Britain as a public school). There he spent the years during World War I, excelling in drawing, acting in school theatrical productions, and laying the foundation for his later success at Cambridge University. Too young to serve in the war, he entered Magdalene College in 1919 to study Modern Languages with the intention of eventually becoming an architect. Magdalene College was largely filled with the sons of landed aristocrats, the influential, and the rich. Fitting into none of these categories, he relied on his personality and sense of humor to gain a wide circle of friends. On joining the legendary Cambridge University Footlights Dramatic Club, he designed and wore his own creations in a number of productions, spending more time on these shows than on his academic work. He and his father battled with the college to keep him there, but he left without a degree. His father refused to pay for another year of academic failure, and by then, Hartnell was mourning the death of his beloved mother.

His Cambridge finale was the 1922 Footlights production *The Bedder's Opera* (a "bedder" being the Cambridge term for a woman cleaner of undergraduates' rooms). Based on a fashionable revival of John Gay's eighteenth-century masterpiece, *The Beggar's Opera*, the production was a showcase for Hartnell's talents. At a time when few women were admitted to the university, men usually performed the women's parts: Hartnell excelled as Gwen. It was an accolade for Daly's Theatre in the West End of London to take on a production of the farce, which was reviewed by Corisande, the influential Minnie Hogg of the *Evening Standard*. "Is the British dress genius of the future now at Cambridge?" she asked the world.

Inspired by this and the encouragement of his friends, Hartnell sought work in the grandest London dress houses, with little success. He decided finally to set up his own business on St. George's Day, April 23, 1923. His sister Phyllis and his father, together with an Edwardian boulevardier, the enigmatic publicist and promoter Richard Fletcher, all backed him, and he was portrayed by the press until the 1930s as the "young Varsity designer." He made headlines early on, winning a court action against Lucille, the sister of Elinor Glyn and owner of that dress house, who had stolen and published Hartnell's designs after his short, ill-fated employment with her.

Opening a salon at 10 Bruton Street in Mayfair, London, he showed his first collections in 1924. The dresses displayed his acute awareness of line and a luxurious approach to designing elaborately feminine clothes, which he subsequently refined to an art. His study of nature, begun in Sussex and Cambridge, was distilled into his own color sense and applied to the choice of materials of varying textures. Hartnell's first clients were the sisters and mothers of his Cambridge friends. His fashion shows were fun and well staged. He began his tradition of

OPPOSITE Photographed on the eve of the Royal Tour of 1954, the glamorous young style of the radiant Queen Elizabeth II is displayed to perfection. The crinoline line evolved to give a sumptuous effect of a fully gathered embroidered skirt beneath a tiny waist and low-cut bodice. The dress, highlighted by the blue ribbon of the Order of the Garter, is both a statement and a background for the magnificent jewels.

giving each dress a witty name like "Grandma's Garnets" or "Goosey Gander," which became a House of Hartnell tradition. The shows were talked about and written up, and his business grew throughout the Jazz Age, when the clothes worn by the fashionable and beautiful were chronicled in newspapers and the quest for youth first began. His designs for actresses on and off the stage and screen provided crucial publicity. Following Worth's ideal rather than the extreme flapper look, Hartnell produced romantic clothes with simple silhouettes. Like Worth, he designed for many social activities centered on and around the Royal Courts, with their debutante parties and presentations. During the season, society women did not usually wear the same dress twice, which made them wonderful customers. In the 1920s, such women bought their clothes in Paris, and it was more their jazzy daughters Hartnell sought to influence.

By 1927, Hartnell, who had become the darling of British fashion, had the audacity to take his collection to Paris. It made good headlines, but proved bad business, for his clothes could not compare in their construction to French haute couture. After hiring new fitters and seamstresses, he returned to Paris in 1929 to open his own house at 33, rue de Ponthieu, off the Champs Elysées. By showing longer skirts he set the new fashion, and even the French followed his example. Soon afterward, such French stars as Alice Delysia and Mistinguette became clients. He also sold his dresses to fashionable Fifth Avenue department stores in New York, where his clothes were shown in their windows.

An idealistic young man, Hartnell was reminded by his sister and father of the financial challenges of his profession. "Art as applied to dressmaking, I now realize, must be measured with the yardstick of profit and loss," he wrote. "The same business organization must actuate both a dress shop and a fish and chip shop. After all, the same principles apply to both; buying and selling; getting rid of stock while it is seasonable, and prompt payment." By the early 1930s, many of his young clients became brides, which kept the business flourishing. For inspiration, he often visited museums and galleries, distilling ideas into dresses. Spectacular wedding dresses became his specialty. Society weddings became living tableaux involving the bride, bridesmaids, and female relatives in beautiful dresses—often all from Hartnell—with historic London churches as the setting, and attracting large crowds. The public treated these events as street-blocking theater, and Hartnell profited from the publicity.

It was the 1935 wedding of the third son of King George V and Queen Mary, Prince Henry, Duke of Gloucester, to a daughter of the Duke of Buccleuch, Lady Alice Montagu-Douglas-Scott, that brought Hartnell the patronage of the Royal Family. Although no royal lady could have failed to notice Hartnell's designs, which were worn by so many debutantes and their mothers to the many events on the royal calendar, it was this wedding that brought the Duchess of York, mother of Princess Elizabeth and Princess Margaret Rose (two bridesmaids) for a visit to Hartnell's sparkling-new art moderne mirrored salon at 26 Bruton Street. The Duchess met the designer and clearly approved of everything she saw. When she became Queen Consort on the Abdication of King Edward VIII, she was already a client of Norman Hartnell's.

In the wake of the Abdication, the creation of a new image for the Queen became Hartnell's vital task. He was guided by the King to view the crinoline dresses depicted in portraits by Franz Xavier Winterhalter in the private Royal Collection. Hartnell reinterpreted the crinoline for the Queen's wardrobe, which was acclaimed during the State Visit to France in 1938 and the 1939 Royal Visit to Canada and the United States. On the eve of war, cementing political ties was essential for Britain. The King and Queen's easy charm, along with Hartnell's ingenious designs, generated goodwill and publicity for these events, leading Adolf Hitler to remark that the Queen "was the most dangerous woman in Europe."

The French applauded Hartnell's romantic designs for the Queen, which made the brittle chic of her sister-in-law, the Duchess of Windsor, seem démodé by comparison. The French press reflected public opinion, one headline stating: "Today France Is a Monarchy Again." France recognized Hartnell's revolutionary fashion achievement by appointing him Officier d'Académie. During this visit, he developed friendships with two young designers, Christian Dior and Pierre Balmain, who would both open their own couture houses after the war.

By the outbreak of World War II in 1939, Hartnell's success attracted French houses, such as those of Edward Molyneux, Maggy Rouff, and Elsa Schiaparelli, to London. During the war he supported the fashion industry and his country's economy by joining with nine other London houses to found the Incorporated Society of London Fashion Designers, modeled after the Parisian Chambre Syndicale. During the war, Hartnell had to scale down his business, yet he created Export Collections for neutral countries, designed for clients if their coupons and regulations allowed, or altered clothes and hats to refresh outfits. The Queen was subject to the same wartime restrictions, and Hartnell continually worked with her to judiciously update her wardrobe. Under the Berkertex label, he became the first great designer to create mass-produced dresses. His 1944 Latin American Exhibition of national costumes toured Britain, raising money for service charities and ensuring a high profile in South America. When he took a special Export Collection there in 1946, Argentina's Eva Peron became a client. On a visit to London in the early 1950s, Christian Dior, creator of the New Look, publicly acknowledged Hartnell's influence: "Whenever I try to think of something particularly beautiful, I think always of those lovely dresses that Mr. Hartnell made for your beautiful Queen when she visited Paris."

Hartnell's postwar success was not entirely based on the patronage of the Royal Family, though he was celebrated for the clothes he designed for the 1947 Royal Tour of South Africa and Rhodesia as well as Princess Elizabeth's wedding dress. He began to be recognized for having the ability to bridge the generation gap, creating an individual style for his clients, rather than being a fashion instigator. By the time of the Coronation of Queen Elizabeth II in 1953, Hartnell's versatility was formidable, and he continued to design for an increasing number of Royal Tours and Visits. These designs would make fashion news worldwide and were often copied. His last royal wedding dress was for Princess Margaret in 1960, reaffirming his mastery of line and technique on a grand scale while demonstrating that, at nearing sixty, he could still manage a great coup de théâtre.

Through all his years, the British countryside was a refuge and inspiration for Hartnell. At his Windsor Forest house, Lovel Dene, which he acquired in 1934 and continually redecorated until he left in the mid-1960s, he observed the colors of the passing seasons and utilized them in his designs. For a time, he also had a London townhouse in Regents Park filled with antiques. Yet he always returned to his rooms above the salon in Bruton Street, where he also designed and supervised the creation of perfume, shoes, furs, menswear, jewelry, automobile interiors, and ready-to-wear, together with the making of successive collections.

To mark the Jubilee of 1977, Hartnell was appointed a Knight Commander of the Royal Victorian Order, a personal appointment by the monarch. When he attended the event at Buckingham Palace he was surprised and moved that the Queen had arranged for Queen Elizabeth the Queen Mother, his great patron, to perform the ceremony on her behalf, a fitting climax to a remarkable career of six decades that transcended mere fashion, creating an individual, enduring British style. —Michael Pick, London, August 2007

OPPOSITE Queen Elizabeth II and Prince Philip receive President and Mrs. John F. Kennedy at Buckingham Palace in London on June 5, 1961. Jacqueline Kennedy's dress from Chez Ninon displays the evolution of the straight silhouette, while the Queen remains true to the final flowering of the Hartnell crinoline design.

LEFT Photographed in 1905, a very young, curly-headed Hartnell was already familiar with picture hats and wide, lace-embellished collars.

OPPOSITE The successful young designer was photographed in 1938 at Lovel Dene, his country house in Windsor Forest. Although hearty sports were not Hartnell's first love, he was passionate about nature and his animals. Born in an era when horses were usually seen on the streets of London, he learned to ride as a boy with his father and older stepbrother.

ABOVE During his last term as a boarder at the Mill Hill School in 1919, Hartnell (back row, far right) was a member of the Third XV Rugby team and was also known for his prowess in theater productions.

ABOVE As a Cambridge University undergraduate, Hartnell (front row, fourth from the left) wore a design of his own creation, sporting a flamboyant feathered picture hat for a Footlights Dramatic Club production that included his lifelong friend, the Reverend Richard Blake-Brown, a novelist and eccentric clergyman (front row, seventh from the left).

ABOVE Hartnell is shown in the mid-1960s, surrounded by members of his workforce, including fitters, cutters, embroiderers, a furrier, and a tailor, grouped around a house model. Madame Jeanne, the directrice of the salon, is to his right; Miss Louie, the stockroom controller, who worked for him for forty-seven years, is to his left.

ABOVE Hartnell, front row second from the right, was photographed in the mid-1960s with leading members of the Incorporated Society of London Fashion Designers. Fellow royal designers are Ronald Paterson, top row left, who designed for the Queen of Jordan, John Cavanagh, top row center, a favorite designer of Princess Marina, Duchess of Kent, and Hardy Amies, front row second from the left, by Appointment to the Queen.

Hartnell was portrayed by many of the most famous photographers of the twentieth century, as well as by numerous artists. A wartime sketch by Jonas captures his pensive mood, this page, while Paul Tanqueray took the soft-focus photograph, opposite, in 1938.

WITH A TOY MERRY-GO-ROUND, AND A PATCHWORK CURTAIN
CONTAINING A SCRAP FROM EVERY DRESS HE HAS DESIGNED:
MR. NORMAN HARTNELL.

PREVIOUS PAGES LEFT As the young British dress genius of the postwar years matured, Hartnell was the subject of perennial press interest. In a 1930 article in the *Sketch*, he was photographed against a patchwork made from scraps from every dress he had designed.

PREVIOUS PAGES RIGHT In the 1920s, Hartnell relaxes in the chic Bohemian surroundings of his suite of rooms in London's Clarges Street, Mayfair.

RIGHT During a 1938 summer break on the Riviera, in Monte Carlo, Hartnell was dressed with typical flair, down to his unusual two-tone shoes.

LEFT Always inventive, Hartnell marked the end of the 1950s with his evolutionary play on the late nineteenth-century bustle, transforming it into the Peacock Line. The bustle emanates unexpectedly from a short, horizontally gathered evening dress, with a low neckline balanced by sensual three-quarter-length gloves.

RIGHT A caricature of an ebullient Hartnell shows him clutching an armful of designs, surrounded by a bevy of soulful women in elegant clothes, apparently at odds with his breezy and countrified appearance.

The Queen's Dressmaker

From his headquarters in Bruton Street, Norman Hartnell, dressmaker to the Queen, produces 50 complete outfits for the Queen each year, and fashion styles which are followed all over the world.

LEFT *Picture Post*, first published in the late 1930s, was directly influenced by the advanced format of German photographic weekly news journals. It proved an instant success and, almost from the beginning, regularly featured Hartnell innovations.

OPPOSITE In the 1940s, Hartnell was photographed sketching in his studio dressed in a natty tweed suit, with new designs for the Queen and Princess Elizabeth. Treating his work as a regulated occupation, he seldom waited for inspiration, but rather sat down for regular sessions with his drawing board and various materials.

The Queen's Dressmaker Takes An Important Order
Half Norman Hartnell's day is spent in telephone conferences; with his most important clients about their dresses; with manufacturers about materials; with his own workrooms about the making-up of models.

Hartnell Roughs Out a Design
First the rough idea; then the translation of the idea into material and measurements, and the choice of accessories to go with it.

IT was chance that made tall, well-built Norman Hartnell into a fashion-designer and the owner of one of the leading fashion-houses in this country.

Hartnell was up at Cambridge. Every year the undergraduates produced plays. Hartnell designed the costumes and settings for these productions. Taking part also in the performances, he proved himself a startlingly clever female impersonator.

Eventually, as a member of the "Footlights" club, he collaborated in writing "The Bedder's Opera." (A "bedder" is a Cambridge charlady who specialises in the cleaning of undergraduates' rooms-in-college.) The play ran for one uproarious afternoon at Daly's Theatre in 1924.

The dresses designed by Hartnell for these undergraduate shows attracted attention. On coming down from the University he and his sister opened a small shop in Mayfair, with three work-girls and a sewing machine. He was the latest in the direct line of succession to Worth, who surprised the world by becoming its first male modiste. From these amateur beginnings Hartnell set out to challenge the supremacy of the French designers.

To-day the House of Hartnell

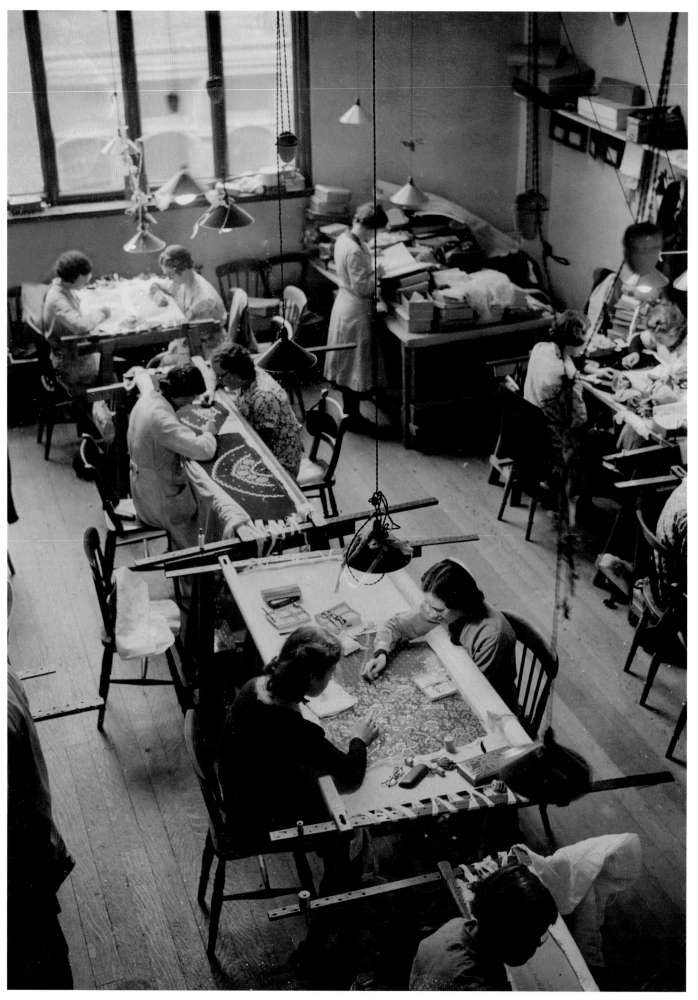

LEFT Away from the lavishly decorated salon and fitting rooms of the House of Hartnell at 26 Bruton Street were floors of modern workrooms housing the many skilled members of each department. The 1940s view of the embroidery workroom reveals the intensive and time-consuming specialist skills involved in creating hand-stitched clothes, the finest hallmark of Hartnell designs.

OPPOSITE In 1972, with almost half a century of experience in business, Hartnell, second from right, stands in the stockroom consulting key members of his staff over the choice of fabrics.

RIGHT The Hartnell workroom engagement book details appointments with the Queen Mother, the Queen, and Princess Margaret. Royal patronage formed the backbone of the business from the 1940s onwards. The designer and his staff would personally attend the various royal clients to discuss designs and for the vital fittings, at which time Hartnell would remain outside the fitting room until summoned to view his creation and receive any comments. It was rare for any member of the Royal Family to visit the salon.

BELOW RIGHT The intricacies of accounting for every component of a design are revealed in one of the firm's notebooks. The control and costing of each item of stock remains an essential part of the financial side of running a fashion house.

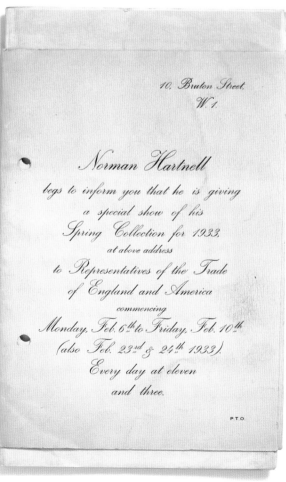

LEFT With the exception of the war years, Hartnell, whose passport is shown here, made regular trips to Paris, where he maintained his own salon during the 1930s. He first visited New York in the late 1920s and was in South America with a special Export Collection in 1946. Later, he promoted his products with personal visits throughout the British Commonwealth, the United States, and Europe.

BELOW LEFT Understated elegance, the mood of the new building at 26 Bruton Street in the mid-1930s, was embodied in the Hartnell Green of this fashion show program cover and the formal invitation to view collections at his first premises.

OVERLEAF LEFT Hartnell was more than adept at creating a variety of gorgeous dresses on glamorous girls, whether in his salon shows or on stage or in film, as shown in this still from the 1935 movie *Brewster's Millions*. In this English musical, a group of forgotten beauties all delight in the slumbering figure of another, asleep in a wing chair of outsized proportions. Freed from the static image of the fashion journal, his designs moved and breathed across the screens and into the dreams of millions of women.

OVERLEAF RIGHT On their return from a Royal Tour of Northern Rhodesia (now Zambia) in 1954, the Queen Mother and Princess Margaret leave the plane with the Queen, who went aboard to welcome them home. Each Hartnell ensemble reflects the individual style of the wearer, yet was also fashionable at a time when each season brought significant widely copied changes.

Norman Hartnell empfängt die Königin-Mutter und Prinzessin Margaret. Sein erster Auftrag für ein Mitglied der königlichen Familie war das Hochzeitskleid für die Herzogin von Gloucester im Jahre 1936. Diesen Auftrag erhielt er ohne besondere gesellschaftliche Verbindungen. Er sandte Entwürfe an sie, die von ihr gebilligt wurden. Bald darauf arbeitete er schon für die Königin-Mutter — die damalige Königin — und für ihre beiden kleinen Töchter. Und heute wird jede Kollektion zuerst der Königin vorgelegt.

Norman Hartnell

MODEKÖNIG DER KÖNIGIN

Von unserem Londoner M.E.-Korrespondenten

→ Norman Hartnell macht alle seine Entwürfe selbst. Am liebsten arbeitet er in einem kahlen, weißgetünchten Dachzimmer seines Landhauses in Windsor, wo unser Bild aufgenommen wurde . . .

Der Herr, der an einem Dezemberabend in einem Tanzpalast des Londoner Westends saß, schien nicht ganz hinzugehören. Es war eines jener billigen und überfüllten Lokale, mit Talmi-Prunk ausgestattet, in die Stenotypistinnen und Verkäuferinnen von ihren Freunden ausgeführt werden, um Tanz mit dem grimmigen Ernst der Jugend zu betreiben. Der Herr war nicht mehr der Jüngste — aber er war zu soigniert, zu offensichtlich aus einer andern Welt, um zu dem Typ älterer, anschlußsuchender Männer gerechnet zu werden, die in diesen «Palästen» nicht selten sind. Im Laufe des Abends näherte er sich einem jungen Mädchen — dann einem zweiten, einem dritten und einem vierten. Er wechselte nur wenige Worte mit ihnen, aber es ist wahrscheinlich, daß diese Auserwählten die Worte des fremden Herrn nie vergessen werden. Er sagte nämlich — mit geringen Variationen: «Mein Name ist Norman Hartnell — und um jedem Mißverständnis vorzubeugen, mein Interesse ist rein beruflich. Ich

bewundere Ihr Kleid. Sie haben einen ausgesprochenen Sinn für Mode.»
Als Harun al Raschid sich noch verkleidet unter das Volk von Bagdad zu mischen pflegte, konnte die Enthüllung seiner Identität kaum eine größere Sensation hervorrufen; und seine goldenen Gaben konnten kaum mehr beglücken als dieses Lob Norman Hartnells. Auch er ist ein König, der unbestrittene Modekönig von England. Und er ist ein Idol der Frauen. Vor kurzem wurde er in einer Stadt in Nord-England von 4000 Frauen erwartet wie ein Filmstar. Sie stürzten sich auf ihn, sie zerrten an seiner Krawatte, an seinen Manschetten, an seinen Haaren, und sie schrien triumphierend: «Ich habe ihn berührt! Ich habe ihn berührt!» Norman Hartnell war sehr dankbar für diese freundliche Aufmerksamkeit, fand aber das Erlebnis einigermaßen erschreckend.
Wie jeder wahre König, wirft auch er seine Bürde nie ab. Er besuchte den billigen Tanzpalast, um zu sehen, wie sich kleine Londonerinnen mit ein paar Pfund kleiden, und unter Hunderten sah er vier Kleider, die ihm gefielen und ihn anregten. Sein Beruf hängt von Inspiration ab und besteht daher aus einer ständigen Suche nach Anregungen. Sie kommen oft, wenn er sie am wenigsten er-

Madame Denise, eine der Damen an [der] Spitze der Hartnell-Hierarchie von [?] gestellten. Sie überwacht äußerst g[?] Anproben der Königin im Buckingha[m]

LEFT Hartnell made international headlines throughout his career, as can be seen in this late 1950s German magazine article. He visited Germany several times from the 1950s onwards to promote his clothes with shows in Hamburg and Baden-Baden and, later, in connection with his menswear designs.

OPPOSITE In 1956, the individual Hartnell styles of the Queen and the Queen Mother are perfectly in tune with the context of the elaborate historic robes of the Lord Mayor of Westminster, as they were with any of the varied occasions of state and ceremony in which they were worn. The fashion of the period is exemplified by Mrs. Gerald Legge, later Raine, Countess Spencer, stepmother of the late Princess Diana, wearing a ruched and embroidered paneled crinoline dress, perfect for performing a deep curtsey.

OVERLEAF LEFT On a sunny day in the late 1930s, the doorman at 26 Bruton Street helps Hartnell into his dashing Lagonda sports car. Behind them is visible the demolition of part of old Bruton Street, including the house from which Lady Elizabeth Bowes-Lyon left for her 1923 marriage to His Royal Highness Prince Albert, later King George VI. Queen Elizabeth II was born there in 1926.

OVERLEAF RIGHT Across the street, the House of Hartnell at 26 Bruton Street, seen here around 1960, displayed the designer's two Royal Warrants above the marble surround of the impressive front doors of the salon, designed by Gerald Lacoste in 1934.

ALL THAT JAZZ

At the dawn of the Jazz Age, Norman Hartnell was an undergraduate of Magdalene College, Cambridge, accepted among his socially superior peers because of his wit, style, and sunny disposition. He studied Modern Languages, but in common with successive generations, found his métier in acting and designing for the Footlights Dramatic Club, which was "largely made up from the current polo-playing, gambling, sporting set to which I did not belong," he wrote. "I tried to make myself useful, designing posters and programmes, scenery and dresses." When the Club went to London to perform their show called *The Bedder's Opera*, a member of the audience, a writer for the *Evening Standard*, was bowled over by the costumes.

"I'd hate to presume to advise an undergraduate on his future career, but the frocks in *The Bedder's Opera* given by the Footlights Dramatic Society yesterday set me thinking as to whether Mr. N. B. Hartnell wasn't contemplating conquering feminine London with original gowns," wrote Minnie Hogg, the columnist known as Corisande.

Hartnell took the suggestion and decided to pursue a career in fashion instead of architecture, as he had once planned. His first real job taught him that he did not have the temperament to be a tailor, but that did not deter him. "My three month's experience had convinced me that I did not want to be a dressmaker," he wrote in his 1956 autobiography, *Silver and Gold*. "I never considered myself one, neither do I now. I am a designer."

Because he did not worry too much about the construction of a dress nor spend hours draping fabric on mannequins, Hartnell was free to allow his imagination to roam as he sketched elaborate gowns for the society women of Mayfair. He was lucky that two strong-willed women came to work for him and helped to execute his grandiose visions: Miss Doherty, who had worked for the famed Edward Molyneux in Paris and claimed to have masterminded his success, and the French fitter she hired, Madame Germaine Davide, known as "Mam'selle." Without them, his business would have failed. "Helped by these two meticulous women, who judged the value of my proffered sketches and advised on style and cut respectively, my work took on a new aspect. I was beginning to understand how much lay between the designing of a dress, which gave me intense pleasure, and its transformation into something that women would buy."

It was Mam'selle who understood why the women of London were reluctant to buy his clothes at first. "Every English lady wishes for something that is French," she told her boss. "If it were not for the pure beauty of your dresses you would not sell a single one." Or, as Hartnell summed it up, "I suffered the unforgivable disadvantage of being English in England."

Together, they created Hartnell's collection for Paris in August 1927. The newly opened Hotel Plaza Athénée was chosen as the location, but very few store buyers were present. After the show, a *Vogue* editor named Main Bocher (later the celebrated designer known as Mainbocher) told Hartnell what was wrong with his collection: "I have never seen so many incredibly beautiful dresses so incredibly badly made."

Two years later Hartnell returned to Paris with his impeccably made clothes. These dresses were a success with buyers from America's leading department stores. Moreover, he was offering an alternative to the era's flapper dresses before the Parisians did, and he enjoyed citing the following, written in *Harper's Bazaar* by Baron Adolphe de Meyer, the photographer and journalist, "Paris dressmakers cannot claim the new long dresses as their own innovation. Long dresses were brought in by young Mr. Norman Hartnell from England last year."

Hartnell became sought after. His initial clientele was drawn from the mothers and sisters of university friends attracted to the salon at 10 Bruton Street, Mayfair, but word of his ingenuity soon drew stars of stage and screen, including Gertrude Lawrence and French star Mistinguette. Great New York specialty shops such as Best & Company and Russek's (which was owned by the family of photographer Diane Arbus) featured his dresses in their windows. Everyone seemed enchanted by the amusing names he gave his creations, such as "Miss Muffet," "Little Pickle," and "Goosy Gander."

Hartnell's wit and drama was not limited to dressmaking. In 1928, when he gave the celebrated Circus Party, he turned a ballroom in Bruton Street into a circus ring, with acrobats and performing wolves prowling the stairs. The buffet was decorated with animals carved in green ice. Hartnell was a celebrity. He had arrived.

RIGHT In 1929, Hartnell, far left, appeared nationwide in an early movie newsreel as he was leaving for Paris by air with his models and new collection.

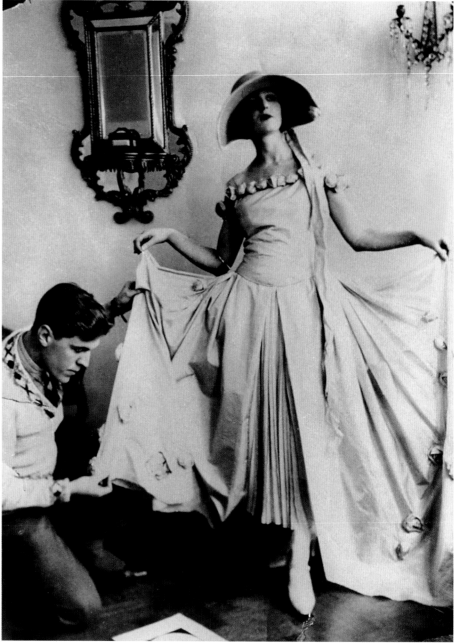

ABOVE Hartnell works on a very early design in his first premises at 10 Bruton Street, Mayfair, London in 1924. The silk turban of patterned velvet shows the clear influence of Paul Poiret, the famous Parisian couturier of the time. Hartnell could neither cut nor sew. He sketched each detail and was inspired by the drape and fall of the materials he liked to use.

ABOVE In the winter of 1924, Hartnell, in a casual pullover, adjusts an afternoon dress of ruched and pleated silk with extending side panels on a model, his cousin Constance Barnett. The dramatic effect of the gown, with its Poiret-like rosebud-strewn fabric, is reminiscent of his designs for *The Bedder's Opera* of 1922.

OPPOSITE One of the designer's best early clients, the actress Elsie Randolph, shows off one of Hartnell's ultra-chic and novel 1925 lounging pajamas in the salon at 10 Bruton Street. The luxurious outfit of satin and pleated and draped chiffon has lavish fur cuffs added to the jacket and pants. The small, jaunty hat provides an extra touch of Hartnell fun.

ABOVE A 1929 velvet evening coat lined with silk crêpe has deep horizontal tucking at the hem and a wide ermine collar with tails. The silk crêpe dress has a low waist and gathered tiers forming the long skirt. The neat shingled hairstyle epitomizes the Jazz Age woman at the end of the decade.

ABOVE A sensual ensemble from 1924 includes an evening cape, the wide collar embellished with velvet roses, worn over a long, pale satin dress, and pays homage to Poiret. With figured and patterned velvet and deep satin tiers edging the draped coat, the outfit is worn by Constance Barnett and typifies Hartnell's early designs.

ABOVE A clinging velvet chinchilla-weighted evening coat frames a figure-hugging, flounced, lace-trimmed long evening dress and marks the end of the 1920s.

ABOVE A debutante's Court dress of 1927 of fine silk organza has a scalloped design on the bodice which echoes the handkerchief hemline. A tulle veil and the obligatory three Prince of Wales feathers are worn with a bandeau pushed high on the model's head. The ostrich feather fan was the usual accessory, and satin shoes complete the neat ensemble. Long white gloves, not shown here, would be worn.

OPPOSITE TOP ROW Although it was not his favorite activity, designing day dresses was an economic necessity for Hartnell. A group of representative day outfits of the 1920s in wools, velvets, silks, and linen were as inventive as his designs for evening dresses and include a geometric-patterned linen coat and skirt that shows how Hartnell was able to turn a little nothing into a fashion statement.

OPPOSITE BOTTOM ROW The Hartnell evening dress evolved during the 1920s, illustrated by the ingenuity with which he designed and draped fabrics using the bias cut to achieve the perfection of long or short dresses, with accessories such as ostrich feather fans, fur trimmings, and embroidery.

RIGHT The Dracula dress of 1929 was one of Hartnell's best-selling and most publicized original designs. Worn by the celebrated beauty Lady Sylvia Ashley (later Mrs. Douglas Fairbanks, Sr.), the dress was of heavily shirred and tiered taffeta beneath a net bodice, with ruffled side panels leading to a peacock train. The innovative boned side panels were designed to be worn either up or down. The workroom mastery of the intricate construction is apparent.

Miss Isabel Jeans

The TATLER

Dorothy Wilding, Old Bond Street

MISS ISABEL JEANS IN "THE GAREY DIVORCE CASE"

Miss Isabel Jeans is appearing as the extremely capable lady in her husband's (Mr. Gilbert Wakefield's) new play at the Court. As Mr. Gilbert Wakefield is a barrister the technical detail in the trial scene is naturally above criticism, and Mr. Wakefield also must know exactly how far a spirited witness like Mrs. Garey would go or be able to go with cross-examining counsel and the Bench. The cross-examination scene is the big one, and we all felt rather sorry that Mrs. Garey lost the duel with the quite savage and brutal cross-examiner, especially as she does not deserve to do so, and only makes a false confession in the witness-box to escape from an intolerable persecution. The husband is a bit of an outsider, but the cited co-respondent, one Arthur Cappering (Mr. Jack Hobbs), the worst type of thick-eared young bounder that can be found. It is an ingenious play, and the heroine gets all the sympathy

HOW LIKE GRAN'POP! —

WITH DELYSIA.

Having seen this handsome monkey on the stage of the Gaiety, where he is appearing in "MOTHER OF PEARL" with MLLE. ALICE DELYSIA, we think that it must be our own Lawson Wood GRAN'POP making a stage début without having told us! At all events, the likeness is very striking.

PHOTOGRAPH BY SASHA.

OPPOSITE Hartnell dresses were increasingly seen on the London stage during the 1920s. French musical star Alice Delysia, below left, who became a friend, wore his clothes in a number of productions. Her most famous appearance was in C. B. Cochran's 1933 *Mother of Pearl*, in which she wore an array of stunning fitted sequined evening gowns. They had evolved from such late 1920s designs as those worn by Isabel Jeans, top left and right, in the plays *Miss Adventure* and *The Garey Divorce Case*. The tailored line, in fitted and draped satin, is matched in elegance by the turban.

RIGHT A 1928 evening dress of silver and white silk tissue over net, with its closely fitted bodice, an open back, and shoulder straps, heightened the sophisticated illusion of the floating skirt. The semi-crinoline effect is evidence of Hartnell's early preoccupation with the crinoline line he was to promote in the late 1930s to world acclaim—a version of which had already been seen in the dresses of the period for brides and bridesmaids.

OPPOSITE Hartnell day and evening clothes marked the transition from the 1920s to the 1930s with closely fitted, elaborately constructed designs, indicating the fine craftsmanship of his workrooms. The inventive details extended to the use of fur trimmings and the sense of movement inherent in the tiered or draped lines. In 1930 Hartnell was acknowledged as the first designer to effectively abolish the short evening dress after a long period of popularity in Paris, London, and elsewhere. This was the first time he caused an important change in the silhouette of women's dress worldwide, particularly in evening wear.

RIGHT Polka dots were a favorite youthful touch for Hartnell summer clothes in the late 1920s and early 1930s, when women often visited the Normandy resort of Deauville or the French Riviera, or took a cruise. The playful color combinations are emphasized by the sketch for a similar dress with the typical Hartnell addition of a clutch bag, far right. Marjorie Brooks, the actress, wore a version of the design in the 1930 production of *It's A Boy*, left.

LEFT The medieval theme of the skirt of this 1929 evening dress of great complexity has thin hanging panels interspersed with silk net, reflecting Hartnell's famous wedding dresses of the period. The body of the dress is encrusted with sequins in darker shades that form the leaf patterns. The elegance of the low back enhances the grace of Lady Sylvia Ashley, a society beauty of the period. Said to have been the daughter of a milkman before becoming an actress, she later married Douglas Fairbanks, Sr., and then Clark Gable. She died in Hollywood, California, as Princess Djordjadze.

OPPOSITE Models from Bonwit Teller, the New York department store, were sketched by the famous illustrator Pagès in 1931. The peach silk-taffeta summer evening dress by Hartnell, right, is notable for its gathered waist and the puffed sleeves that were popular in the 1930s. The other is a more conventional long-sleeved design from Augusta Bernard's Parisian house.

AUGUSTABERNARD AND NORMAN HARTNELL MODELS FROM BONWIT TELLER • FURNITURE DESCRIBED ON OPPOSITE PAGE

All the accessories for an evening on the terrace

LEFT Shown in May 1929, the communicating doors by Courtois et Detrois of the Norman Hartnell salon in Paris, at 33, rue de Ponthieu, are a tour de force of period metalwork. The fantasy of the bunches of grapes in amber, green, and amethyst glass created a sensational effect when lit by small, concealed lightbulbs. The interior design of the salon, an intriguing blend of English chintz and the softer side of 1920s French decoration, avoided the harsher angularities of the art deco style. The Paris salon was active until the late 1930s.

OPPOSITE Evening dresses from 1930 to 1933 reveal the dexterity with which Hartnell could create variations on a theme, utilizing a number of combinations of fabrics and materials. Examples include a dress chosen by Lady Weymouth, one of his early brides; the tightly fitted 1930 Circus Cissie, complete with fishtail train in black-and-white crêpe, bottom row, far left; and a 1933 gown with an architectural use of heavily ribbed black-and-white satin that was worn by the strikingly blonde Mitford sister Diana, Mrs. Bryan Guinness, who later became Lady Moseley, bottom row, second from right.

Hartnell dresses from 1932 display an architectural composition that reflected the designer's early aspirations and his visits to New York at the time. A dress with horizontally ribbed satin and organza forming the bodice and floating open sleeves, left, was almost certainly inspired by the Manhattan skyscrapers Hartnell saw at night.

OPPOSITE This dark blue silk-crêpe print dress, with a fishtail, is embroidered with sequins, beads, and paillettes, which were part of a vast stock used into the 1950s and 1960s for Hartnell's handmade Christmas cards.

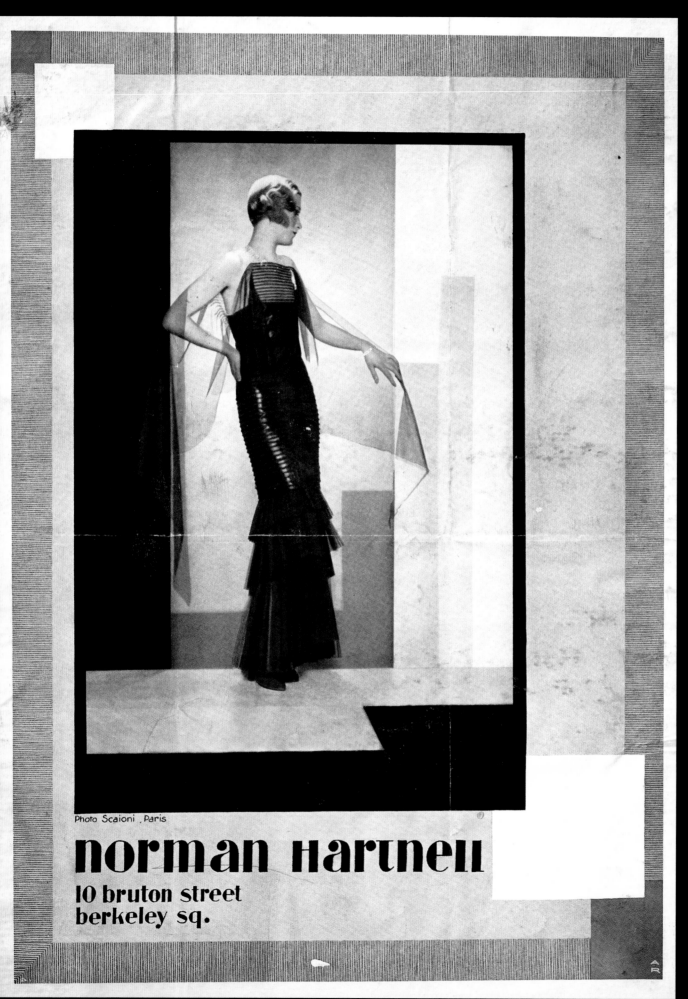

Photo Scaioni, Paris

norman Hartnell
10 bruton street
berkeley sq.

FOXTROT TO THE STARS

During the 1930s, Norman Hartnell began to enjoy the fruits of a successful business that catered to England's wealthiest women. He needed bigger premises and moved his salon across the street to a large Georgian house at 26 Bruton Street, Mayfair. The staircase and showrooms were painted in a color he mixed himself, a silvery celadon he named Hartnell Green, which did not impede or detract from the roughness of homespun tweeds or the silver and gold of bridal gowns. The floors were carpeted in a deep green and the entrance lined with dark green marble. In the salon, facetted mirrored glass covered the columns supporting the ceilings.

Hartnell understood that "In dressing artistes of the music-hall and cinema it is sometimes difficult to over-estimate the value of vulgarity." He also said, "When I gulped hot chocolate with Mistinguette in her Picadilly hotel boudoir, and sipped weak tea with Mae West at the Savoy, I found that both these glamorous women were intelligent and charming, but I realized how much of their great fame and fortune they owed to an excess of sequins and dazzle."

In his private life, Hartnell was more restrained. For his country home, Lovel Dene, his friend, the brilliant architect Gerald Lacoste, transformed a small house into a modern Regency haven of tranquility. He often worked from there: "My house in Windsor Forest becomes a studio when I prepare my collections," he wrote. "At eleven o'clock, I am in the morning room, furnished mostly in carved pinewood with coral velvet hangings, and there I picture the morning suits. Promptly, I sit down at the large wooden desk, place in front of me the samples of materials, and draw them as I imagine them to be worn. . . . At other times, in my pale-coloured drawing-room, I pin lengths of gold tissue to the curtains, watching the fold and grace of the falling stuff, and throw coloured satin across two cushions on the sofa, imagining them to be bust and hips respectively."

Hartnell claimed that "common objects such as slithering sardines or the steel bright lines of a railway station can stimulate ideas if a silver reception gown is wanted" and a "lingering melody or the cloying scent of lilies may suggest a romantic mauve dress for a sentimental matron."

The designer was effervescent with new ideas—this was essential as his clientele expanded. He understood that his clothes came to life only when worn by the right women, and he took care to find suitable models for his fashion shows. "Mannequins are to a designer what actresses are to a playwright," he said.

During the 1930s, Hartnell repeatedly proved that he could stage-manage dress shows, film or stage costumes, and the clothes of his clients. His inherent flair and a sense of the theatrical endeared him to the press, society, actresses, and, eventually, royalty. He would become one of the few designers who could claim truthfully that all the world was his stage.

RIGHT Lovel Dene in Windsor Forest, Hartnell's beloved country house, was remodeled many times from 1935 on, always increasing the charm of the miniature modern Regency house that was built around a cottage from Queen Anne's reign.

LEFT The urban sophistication of the neo-Regency interior created for the country drawing room at Lovel Dene typified Hartnell's taste. The architect was Gerald Lacoste, a talented friend of Hartnell's, who had become the youngest architect ever to be admitted to the Royal Institute of British Architects. He was also an enthusiastic modernist, who excelled in reworking traditional designs, as the designer did in fashion. The authentic antique furniture was updated with modern accessories. Hartnell invented the color of the carpet, which he named Vaseline Green. The interiors were designed by Hartnell and Lacoste using the London decorator Mrs. Dolly Mann, the first commercial revivalist of the Regency style. Mann's young assistant, Norris Wakefield, coordinated the ideas, as he did for the patron of surrealism Edward James at Monkton in Sussex in the 1930s and thereafter for both clients until their deaths.

IDEAL HOME

NOVEMBER, 1947

ONE SHILLING AND SIXPENCE

ABOVE Lovel Dene was used as a promotional tool throughout the time Hartnell lived there. In November 1947, the hall and staircase were featured on the cover of *Ideal Home*, coinciding with Princess Elizabeth's wedding date.

ABOVE TOP RIGHT Each room reflected different aspects of Hartnell's character. The Regency bedroom, with its somber mahogany bed and collection of Staffordshire dogs, was lightened by the amusing rococo grotto chair set against the heavily pelmeted window with its view of the gardens.

ABOVE CENTER RIGHT The study has a touch of the colonial Edwardian military man, with the tiger skin, books, and solid armchair, made informal by the lamps on the chimneypiece. The inlaid Dutch side chair echoes the arched mantelpiece and patterned iron grille of the fire screen.

ABOVE The fantasy of the other rooms is absent from this formal Regency breakfast or small dining room, with its mahogany furniture and glazed cabinets that held some of Hartnell's collection of Bristol glass and antique English porcelain.

Grey flannel suit with woven-in check of slightly darker grey and spot taffeta blouse.

Woollen suit with short loose jacket lined with geometric printed crêpe. Blouse and printed jabot of crêpe.

Marjorie Castle.

Norman Hartnell

Long coat lined with Angora that shows on turn-back cuffs. Tailored Angora dress. Four slits at hem of coat

Digby Morton.

Bunches of Violets scattered over black crêpe with a green suède belt. Sleeves slightly full above wrists.

Flowery printed silk gabardine suit with organdie blouse.

Norman Hartnell

Springs Newest Colours—Violet, Lilac and Cyclamen Pink

Victor Stiebel.

ABOVE If Hartnell was less interested in day clothes, his designs rarely showed it. The ingenuity of his designs for country clothing lent them an added distinction, due to his affinity with fine materials. He used English woolens and Scottish tweeds, all cut and fitted by London's finest craftswomen.

ABOVE Set in the context of two younger London designers, Digby Morton and Victor Stiebel, Hartnell clothes of 1934 display an extra twist of elegance, reflecting the designer's particular zest for life.

OPPOSITE Satin, crêpe de chine, and crêpe are the inspiration for three different designs all adhering to the same fashionable Hartnell silhouette. Each of these 1935 dresses would express the character of its wearer while giving her a different image. All would be flattered by the effect, which relied upon the accomplished fitting and cutting of his workrooms.

LUNCH IN TOWN

The frock which has the debonair air of not being too dressy while subtly conveying that really it is a festive frock, is such a boon. Norman Hartnell knows just the art of such clothes, and here are three examples. The first of printed satin with soft cowl neck-line and wide armhole. The second a gay and charming creation in striped crêpe-de-Chine. Lastly, a most becoming dress in the fashionable dusty pink of crinkled crêpe with a cluster of gauging at one side.

No paper patterns are obtainable of any of these models.

NORMAN HARTNELL

The evolution of the 1930s' Hartnell day wear was shown on models depicting various scenes of London life. These designs display the consummate fitting and cutting skills of Hartnell's star workroom principals, who included Madame Germaine Davide—or Mam'selle, as she was known—one of the most highly paid fitters in the business. Though the company was distinctively British, it relied upon the often superior skills of talented Frenchwomen. The fluid lines of the structure of each garment gave them their superb finish. Hartnell was nearly obsessed with the use of fur on his designs and was the first to dye fox in colors such as pink or blue.

FAR LEFT AND LEFT A 1934 spring ensemble of a light coat and dress features dramatic three-quarter sleeves heavily weighted with pale fox, an idea repeated in a similar design using darker tones.

BELOW LEFT A deceptively simple dark dress from 1935 is enhanced by a contrasting midriff-gathered shirred sash.

LEFT The neat plaid fitted jacket and skirt of 1935 are trim enough for walking the moors and disprove Hartnell's apparent disdain for designing elegant country clothes. The wide shoulders and almost leg-o'-mutton sleeves are notable fashion statements of the mid-1930s.

LEFT This 1936 ensemble of a heavily collared three-quarter coat and dress worn with a high inverted pot hat trimmed with feathers was the precursor of the style reworked for the Queen in the years to follow. It is worn here by Fritzi, an early photogenic star mannequin at Hartnell and a former Berlin beauty queen, one of the large influx of refugees and exiles from an increasingly dangerous continental Europe employed in the garment industry.

ABOVE By 1938, the design had been pared down to a draped dress beneath a more simple coat with nutria facings, weighted by sleeves almost entirely covered with fur. The hat stretched the line even higher and marks the end of the accentuated daytime silhouette.

The big event of the London fashion world in 1935 was the opening of the new House of Hartnell at 26 Bruton Street, just across the street from the designer's previous salon. A late-eighteenth-century townhouse was remodeled extensively and attached to the rebuilt rear section to which floors of airy workrooms had already been added by a developer. It was now possible to house all of Hartnell's employees under one roof. Lacoste was the architect of the project. He and Hartnell had visited all the latest Paris salons, determined to create the ultimate modern interior.

LEFT Lacoste was an innovative practitioner of modern design, utilizing glass in technically unusual ways. Hartnell was enthusiastic in fostering the design of his frameless plate-glass doors, facetted mirror–clad walls, columns, and fittings—contrasting with an antique glittering chandelier and lights. The glass chimneypiece was a sensational focal point.

ABOVE The Hartnell workrooms, which faced the mews at the rear of the salon and occupied several floors, were entered by the workforce from Bruton Place.

From the dark green marble entrance and pale green lobby, frameless plate-glass doors led to the ground-floor showrooms on one side or ahead to the wide staircase leading to the first-floor salon. The effect culminated in facetted mirror–clad columns and two large antique cut-glass chandeliers suspended above the house's masterpiece, an all-glass mantel above the fireplace. The room is now protected as a rare example of British art moderne. All the electric lights burned out during the opening show and the models paraded illuminated by candles against the walls and carpet of Hartnell Green.

ABOVE The extensive workrooms at 26 Bruton Street catered to every facet of dressmaking and provided the setting for labor–intensive hand embroidery.

TOP LEFT A view from the entrance door into the salon shows the large windows that overlook Bruton Street at the front of the building.

TOP RIGHT The salon entrance is visible behind the mirror-clad column. All clients would enter through the mirror-framed glass door, above which hangs Hartnell's famous cut-glass galleon sailing ship light fixture.

RIGHT The neoclassical niche facing the famous glass chimneypiece had a low velvet daybed with two bolsters.

FAR RIGHT The Hat Bar in the main salon was for fitting clients with their Hartnell hats and headpieces.

LEFT AND OPPOSITE Contrasting moods of the mid-1930s from the summer and winter collections included Fritzi in a saucy, closely fitted white jacket and long gloves, sporting a jaunty hat that expressed the joys of summer holidays, left, and a remarkably luxurious, heavy bouclé winter jacket and skirt with a wide saucer-shaped collar of Persian lamb's wool emphasizing the tight skirt flaring out from the knees, opposite. The collar also mirrored the sleek British design lines of the chauffered Rolls-Royce limousine in Grosvenor Square, Mayfair, at a time when British winters were cold, but it was warm enough at the Ritz!

The newest line for evening swirls widely from the waist. This is a Norman Hartnell creation in duchess satin

OPPOSITE From the 1930s, a selection of Hartnell evening dresses reflect the extraordinary diversity of style within a style. They include the fitted Mermaid look of the early 1930s, with sequin-encrusted fishtail skirts; velvet and fur-laden winter ensembles and negligees, as exemplified by that worn by actress Leonora Corbett in 1935, with a divided cape of pleated chiffon weighted with fox fur, top far right; and figure-hugging sequins with a contrasting wide revered collar from 1933, bottom far left. The evolution can be seen in the drawing of an early crinoline in 1937, made in heavy satin and with an emphasis on a wider flaring skirt, bottom far right.

RIGHT By 1938, the crinoline line had evolved into the weighted tiered and ruched skirt of a glamorous embroidered evening dress—a natural derivation of Hartnell's late-1920s dresses.

OPPOSITE Each of these evening dresses oozes a sophisticated and controlled sexual message. The body is concealed, yet also revealed by the fitting or draping of sensual fabrics, often encrusted with jewel-like sequins and emphasized by fur. The erotic quality is embodied by a film star of the period, the exotic Merle Oberon, top far right, Alexander Korda's discovery for London Films, who was photographed in the new salon in 1936. She epitomizes the stars who formed Hartnell's stage and film clientele during the 1930s and responded to the sophistication of his designs.

RIGHT A 1936 sequinned evening dress with a draped chiffon bodice and fitted matching short jacket covered in tortoise-shell-colored sequins. The hours involved in sewing rows of such decorations to create the necessary iridescent effect is evident. Hartnell's embroidery workroom was justly famous and employed dozens of women at its peak. By 1939 the designer had almost four hundred employees, many working out of the House in the neighboring buildings.

LEFT An avant-garde design from 1935 of silk and wool crêpe embroidered with a variety of leaf patterns as well as beads and faux stones to create an elaborate cummerbund of dark jersey material at the waist, which is also used for the edging of the neck and sleeves. The Moorish effect was popularized by films at the time, and the technical ingenuity of the sleeves and tunic created without seams was an unusual construction, even for Hartnell.

OPPOSITE On the eve of World War II, Hartnell created this chic late-1938 black crêpe evening ensemble, with a bolero and fitted high-necked dress. A decorative yoke embroidered with Hartnell's favorite lilac-colored beads makes a playful rope pattern interspersed with a constellation of tiny beads on a dark ground.

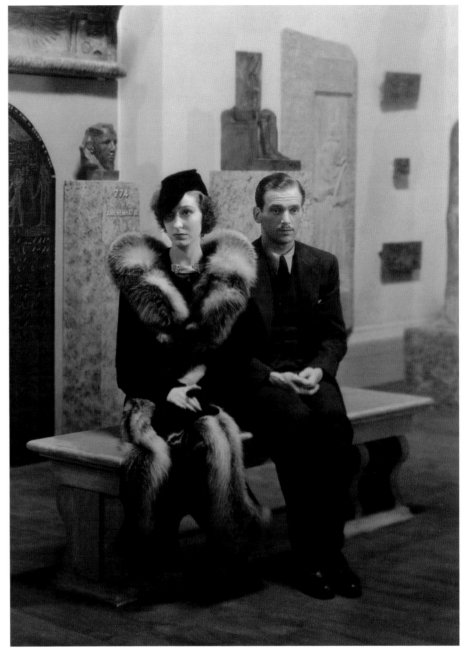

LEFT AND ABOVE The 1937 film *Jump For Glory* (*When Thief Meets Thief* in America) starred Douglas Fairbanks, Jr. (who was also a co-producer) and the young English star Valerie Hobson. Made in the United Kingdom, the film had lavish sets much in the manner of Hartnell's own fashionable neo-Regency interiors. Hartnell designed a series of ravishing clothes for the beautiful heroine.

ABOVE Jessie Matthews was Britain's leading female movie star of musical comedy. Having turned down Hollywood, her stardom fizzled out during the war, but is epitomized here in the 1938 *Sailing Along!* She is wearing a Hartnell fox fur-cuffed evening ensemble of embroidered net tulle for a legendary dance routine that culminated in this famous scene in a streamlined kitchen.

ABOVE *Give Her a Ring*, a 1936 comedy,
gave Hartnell the rare chance to display
an unexpected talent for designing young
women's cycling outfits, a precursor of
his wartime work on Utility designs. The
impracticality of long skirts adds to the
charm of the Basque berets.

WEDDING BELLES

Norman Hartnell became famous for his elegant, intricately embroidered wedding dresses, which made the young women of fashion and position in society each appear uniquely and elegantly different—the test of a good designer. Many of these clients first used him when they were debutantes, subsequently ordering their dresses for their presentation at Court in front of the King and Queen. Strict rules issued by the Lord Chamberlain stated what a woman could wear to meet Their Majesties: long white gloves, a train of a certain length and position, and three Prince of Wales feathers on the head, which could be augmented by a jeweled hairpiece, diadem, or tiara. Hartnell knew how to design dresses that were appropriate, artistic, and even aristocratic.

Hartnell's most famous debutante was Miss Margaret Whigham, who would later become the Duchess of Argyll. "Her perfection of appearance recalls the pink and white of camellias, and her hesitant stutter adds one more charm to this beautiful person who showed the women of her age how to use cosmetics, how to dress, how to be a success, and how to behave whilst becoming one," he said. She remained a client. He not only designed her debutante and wedding dresses but also those of her daughter Frances, who became the Duchess of Rutland.

In spite of his fame, Hartnell remained the dressmaker to almost all his clients, never seeking familiarity or social equality. Weddings were financially important for the House of Hartnell, because he was often responsible for the bridesmaids' dresses and the mother-of-the-bride's ensemble, as well as the honeymoon wardrobe and trousseau. Hartnell was eager to attract prominent clients who would commission luxurious, expensive, and extravagantly embellished gowns, often photographed by the important newspapers and fashion magazines.

When he heard, in the autumn of 1935, that King George V's third son, His Royal Highness the Duke of Gloucester, was engaged to Lady Alice Montagu-Douglas-Scott,

Hartnell wrote a letter, asking if he might submit some designs for her wedding dress. She replied that she would visit him at his salon.

He knew that this wedding would affect the course of his career and hoped that he would be asked to dress the bridesmaids as well, who included Princesses Elizabeth and Margaret Rose, and was delighted when this occurred. King George V, the Princesses' grandfather, wanted them in girlish, short frocks even though the six other bridesmaids would be wearing long Empire dresses. Those designed for the young Princesses were of the palest pink satin with short skirts bordered with three graduating bands of ruched pink tulle, tiny sleeves, and a tulle-bordered bodice. The dresses were accepted by the King and Queen Mary as perfectly executed designs.

Hartnell was summoned to Buckingham Palace to be present while the official wedding photographs were taken in the Throne Room, and he was surprised that the group included not only the bride and groom but the entire wedding party. At one point, a page instructed him to go forward and arrange the Duchess's veil. He approached, bowed, and then knelt to untangle the veil from the spur of the Duke, who wore the blue, damson, and gold of the Tenth Hussars. As he stood up, Queen Mary bestowed the ultimate compliment: "We are very pleased. We think everything is very, very pretty." He had earned the respect of the Royal Family. What would follow was unexpected and a remarkable honor, which Hartnell could not have forseen.

RIGHT At Margaret Whigham's 1933 wedding to the American Charles Sweeny, the bride wore a fashionable fitted medieval dress with an extravagantly long train, complemented by the slinky sideways-moving fishtail dresses of her bridesmaids.

ABOVE In 1925, Barbara Cartland, one of Hartnell's first clients, wore his silver-embroidered tulle presentation dress with the fashionably low waist Hartnell truly despised. Although her mother complained about the price of her dress, Hartnell nevertheless made her ruffle-tiered wedding dress in 1928, designed by Cartland herself. She later wrote that it was a disaster. Hartnell agreed.

ABOVE AND OPPOSITE Mrs. Carl Bendix, the actress Daisy Hancox, wore a pink satin and net dress designed by Hartnell, inspired by medieval forms, in a pageant entitled *The Dream of Fair Women* held in 1928 at Claridge's hotel, then newly remodeled in a sophisticated modernistic style. The embroideries on the skirt and veil as well as the bead and silver chain stitching were typical of Hartnell. The lavish wedding dress was donated to the Museum of London as a dress epitomizing its era—on condition that it would not be put on display until 1960.

LADY MARY THYNNE, daughter of the Marquis of Bath, in the bridal gown she will wear to-day at her marriage to Lord Nunburnholme.

THE TIMES, THURSDAY, NOVEMBER 24, 1927.

FORTHCOMING MARRIAGES.

LORD NUNBURNHOLME AND LADY MARY THYNNE.

Princess Mary, Viscountess Lascelles, and Viscount Lascelles sent an antique white lacquer clock as a wedding present to Lord Nunburnholme and Lady Mary Thynne. The Duke and Duchess of York have given a shagreen inkstand and a circular diamond brooch. The marriage will take place at St. Margaret's, Westminster, to-day, at 2.15.

HAPPY THE BRIDE ON WHOM THE SUN SHINES.—It shone yesterday on Miss Deirdre Hart-Davis and Mr. Ronald Balfour.

MARQUIS'S SON WEDS

Lord Weymouth with his bride, the Hon. Daphne Vivian.

Miss Vivian's bridesmaids leaving the church after the wedding.

Viscount Weymouth, heir of the Marquis of Bath, was married at St. Martin-in-the-Fields yesterday to the Hon. Daphne Vivian, eldest daughter of Lord Vivian. See also page 13.—(Daily Mirror photographs.)

ONE OF THE TALLEST AND LOVELIEST GIRLS IN SOCIETY.

Sir Victor Warrender's little sons, dressed as the Princes in the Tower, acted as pages to the bride.

The bride and bridegroom.

WEDDING PAGEANT IN GOLD.

AGE-OF-CHIVALRY BRIDE.

LADY DIANA COOPER'S NIECE.

AT THE ALTAR.—The picturesque scene in Westminster Cathedral yesterday during the wedding of Miss Hart-Davis, Lady Diana Cooper's niece, and Mr. R. E. Balfour.

OPPOSITE Daphne Vivian was an early client and rare society friend of Hartnell's. For her 1927 marriage to Lord Weymouth, the handsome heir to the Marquess of Bath, Hartnell studied Renaissance and medieval paintings for this embroidered design in satin and net, creating a sensational dress which added to his fame. Hartnell's medieval or Renaissance-inspired designs from the early 1930s formed a developing theme for society weddings in Britain during the decade.

RIGHT The editorial given to Hartnell at this time emphasizes the public perception of him as a designer able to create startling new clothes inspired by the past, using a wide variety of different materials.

NORMAN HARTNELL

This bridal gown, which subtly combines mediæval and modern feeling, is of parchment satin embroidered with pearls, the slim tight-fitting bodice contrasting with a full skirt flaring at the knee. The tiny net yoke is edged with pearls and the sleeve panels and train are of beige shadow lace. A head-dress of satin and pearls holds a tulle veil. The children wear harebell blue satin dresses with yokes of gathered pink net and gauntlet gloves edged with moss roses and harebells, while the bridesmaid's dress is in rose-coloured shadow lace and pale blue satin. All dresses from Norman Hartnell. The bridesmaid's head-dress of pearls in a leaf design is from Jac

THE EARLY SPRING BRIDE AND HER RETINUE

LEFT Hartnell's late 1920s and early 1930s dresses reflected the medieval ideal of virginal beauty that appealed to the designer, having studied Renaissance clothes in paintings in London galleries and museums. He was adept at weighting light, flimsy materials with embroidery, but was also a master of extreme simplicity, as can be seen in this 1934 white satin dress with a long train. Fitters and cutters were headed by Mam'selle, who gave a superlative fit to the best Hartnell dresses.

OPPOSITE A typically narrow-waisted, wide-skirted satin and tulle romantic Hartnell evening dress of 1929 was worn by Lady Plunkett (the former Dorothée Mabel Lewis), when she sat for Philip de László. The artist was highly sought after as the most accomplished portrait painter in the world at that time.

BEAUTIFUL BRIDE'S GOLDEN ATTENDANTS

Mr. Philip Kindersley, Sir Robert Kindersley's youngest son, and Miss Oonagh Guinness leaving St. Margaret's Church, Westminster, after their marriage yesterday. The bride, who is the youngest daughter of the Hon. Ernest Guinness, wore a gown of ivory satin.—(*Daily Sketch.*)

LEFT Hartnell utilized satin embroidered with lilies and trailing patterns of beads with seed pearls extending into the full train of the skirt for Oonagh Guinness' wedding gown. Inspired by Franz Xavier Winterhalter's romantic *The Empress Eugénie Surrounded by Her Ladies in Waiting* of 1885, Hartnell gave the bridesmaids crinoline dresses—a foretaste of his revolutionary revival of the crinoline in 1937.

BELOW Hartnell used the crinoline line again for the wedding of Maureen Guinness, a sister of Oonagh's, to the Marquess of Dufferin and Ava. The sixteen-foot-long veil was as long as the train on the diminutive Oonagh's dress.

OPPOSITE A detail of Oonagh's 1929 wedding dress shows the intricate embroidery that made the House of Hartnell famous.

DAILY-SKETCH

Some of the twelve beautiful bridesmaids who attended Miss Guinness. They wore corn-coloured tulle spangled with golden marguerites, and each carried a sheaf of golden marguerites and corn.—(*Daily Sketch.*)

VICTORIAN DRESSES AT ST. MARGARET'S.

Eleven bridesmaids in ethereal-looking bouffant frocks of white tulle following Miss Maureen Guinness out of St. Margaret's, Westminster, after her marriage yesterday to the Earl of Ava. The bride, whose train was nearly four yards long, set a new fashion by choosing artificial flowers for her maids.

During the 1930s, fashion styles changed radically from year to year. Hartnell's versatility lay in his ability to sum up the fashionable silhouette of the period and rapidly evolve a design perfectly adapted to the character, looks, and bodies of his individual clients. But few women possessed the willowy figures necessary for the closely fitted ideal lines of the period, and Hartnell's clientele considered extreme fashion to be vulgar, only suitable for actresses or the nouveau riche.

OPPOSITE Each presentation or wedding dress reflected a different personality in its use of varying materials and by enhancing the best points of each wearer in the cut or drape of the design. The medieval look, with its extravagant sleeves, could only be worn by the slimmest bride, whereas fuller figures were offset by distracting details at the shoulders or hips. The exaggerated lines depicting the fashionable body of the moment, as drawn in a sketch, bottom row far right, emphasized the early-1930s ideal of tiny waists and long limbs. "Radiant White" was a popular bridal color; the effect could be heightened or augmented by the use of contrasting materials and the many possibilities inherent in the design of a veil, usually used to balance figure and posture.

RIGHT This design depended on a layering technique using vertically gathered silk tulle in the skirt and the draped fichu neckline, while emphasizing the waist with horizontal tucking above a vertical injection of silver lamé.

OPPOSITE Hartnell designs in tulle, net, silk, and feathers augmented by typical embroideries were worn by Margaret Whigham, the most famous debutante of the year in 1930. For her presentation as a married woman in 1934, top center, she wore a dress of coral pink satin with a train of darker coral velvet. She earlier wore a velvet dress to the charity Jewel Ball, bottom center, which shows Hartnell's fascination with Renaissance dress at the time. After she became the Duchess of Argyll, Hartnell dressed her and her daughter Frances Sweeny, bottom row right, also creating Frances' wedding dress when she married the Duke of Rutland.

RIGHT The Duchess of Argyll, far right, and her daughter Frances Sweeny, later the Duchess of Rutland, wearing afternoon dresses designed by Hartnell, center, at a party at Lancaster House in London to entertain foreign fashion buyers in 1954.

Drawn by Robb

● Black velvet evening dress and cape. The cape is magnificently trimmed with three tiers of fox; the lowest tier a double skin.
The dress is regal in its simplicity, the only decoration is in the way the dress is cut in wide horizontal bands down to below the knee. The flaring from there spreads into a fish-tail formation.

● Another day dress with a three-quarter coat is made of grey woollen material, very soft and smooth. It is dark grey with a small overcheck of black. The coat is edged with blue fox, the dress is fastened with pewter Lancastrian roses. The coat has widish sleeves, the dress tight fitting. Note the pointed pockets, the neck tied to a bow.

● Here is an evening dress of a particularly rich shade of red velvet. The colour, like many of the season's colours, has been inspired by those used by the Italian masters of the Renaissance period. It might be called cardinal red. The style of draping is very new at the moment: it is called Venetian blind, a descriptive name. The gathering is in the centre front only.

● Dress and three-quarter coat of black angora with an uneven horizontal chalk line running through it. The neck fastens like the top of a sack. Down the centre front is a folded and pressed back piece of material, giving the effect of a box pleat. Two pewter buttons form the belt buckle, match the button at the neck. White fox dyed black, with the tips remaining white, forms the collar.

● Thunder-cloud blu suit with knee-lengt buttoned and belted front of the coat is co of ermine dyed bl shaded light to dark. fur is worked in ch and there is a thin s the same fur up t straight sleeves. Wide belt with a blue comp buckle to match b military turn-out c

ABOVE AND OPPOSITE In 1935 Andrew Robb, a leading fashion illustrator and a friend of Hartnell's, drew a panoply of the designs for the wedding trousseau of Lady Alice Montagu-Douglas-Scott, a daughter of the Duke of Buccleuch, on her marriage to His Royal Highness Prince Henry, Duke of Gloucester, the third son of King George V and Queen Mary. Although Lady Alice, shown leaving the Hartnell salon after a fitting, right, always preferred rural life, she had a taste for elegant simplicity, and remained a client of Hartnell's and other British designers.

● Another of the Renaissance colours is used in this velvet evening coat: a rich royal purple. The coat is in the grand manner, but it is also an excellent coat for cold winter evenings. The collar is very large, and is composed of arranged, or stitched down, folds. There are full sleeves; the draping of these comes from the seam on the middle of the arm.

Yorkshire Observer
Drake Street, Bradford.
Cutting from issue dated........ 3 0 SEP 1935

Manchester Guardian
3 Cross Street, Manchester.
Cutting from issue dated........ 3 0 SEP 1935

LADY ALICE SCOTT

Lady Alice Scott, who is to marry the Duke of Gloucester in November, after a visit to her dressmakers, in London, during the week-end.

Lady Alice Scott leaving a London dressmaker. She is to marry the Duke of Gloucester on November 6.

BUCKINGHAM PALACE AFTER THE ROYAL WEDDING—OFFICIAL PHOTOGRAPH

photograph taken at Buckingham Palace after the Royal wedding Left to right: Miss Clare Phipps, Lady Elizabeth Scott, the Queen, the Duke and Duchess of Gloucester, the King, Lady Angela Scott, and Miss Moyra Scott. In front are Lady Mary Cambridge, Princess Elizabeth, Princess Margaret Rose, and Miss Anne Hawkins.

THIS PAGE Hartnell's dress for the November 1935 royal wedding of Prince Henry, Duke of Gloucester, to Lady Alice Montagu-Douglas-Scott in Westminster Abbey was overshadowed by the death of the bride's father, which deprived the couple of the planned public wedding. Hartnell's dress was not seen floating up the aisle of the Abbey, as the ceremony was relocated to the Royal Chapel of Buckingham Palace. But the usual series of posed photographs showed the bridal dress and those of the bridesmaids, including the Princesses Elizabeth and Margaret Rose, daughters of the Duke and Duchess of York, below left. Hartnell's own disappointment was mitigated, for their dresses caused the Duchess—later Queen Elizabeth—to make what was to be a historically significant visit to Hartnell's new Bruton Street salon, after which she ordered a number of designs, as did her mother-in-law, Queen Mary.

ON THE BALCONY OF BUCKINGHAM PALACE acknowledging the cheers of the crowds. The King and Queen with the Bride and Bridegroom and Princess Elizabeth and Princess Margaret Rose of York.

To-day's Royal Wedding

RIGHT Hartnell succeeded in his determination for his first royal commission to create a more classically inspired wedding dress than the one made by Edward Molyneux for the 1934 wedding of the beautiful Princess Marina of Greece to Prince George, Duke of Kent, the fourth son of the King and Queen. A Westminster Abbey wedding had seen the draped dress form the centerpiece of a typically royal pageant with flattering publicity. Hartnell's design for Lady Alice was not an all-white gown, but one of pale pearl-pink satin enhanced by a cascading veil, here captured by the revolutionary society photographer known as Madame Yevonde in one of her first color portraits.

LEFT Delicious excess was expressed in 1930 by heiress Maysie Gassque in an outrageously extravagant confection of heavily veiled and trained satin splendor that competed with the wedding cake. Hartnell was equal to the drama of the occasion and the client.

ABOVE Society weddings involved entertaining on a grand scale. For prewar London weddings, Hartnell designed the dresses for the bride, her attendants, female family members, and often those of the groom's family, creating tableaux in church and at the reception.

RIGHT When Jeanne Stourton married
Lord Camoys in 1938, Hartnell designed a
gown modeled on that of her friend,
Margaret Sweeny (née Whigham). The new
design reflected the advance over the five
intervening seasons with the inclusion of
fashionable details such as the tucked
waist and stylized leaf and flower embroi-
deries on the neckline and front of the
cream satin skirt and its nine-foot train.
As with the Whigham dress, the details
released to the press emphasized the
enormous amount of skilled work by the
eighteen women involved in its making,
which required one hundred thousand
pearls and beads, all enhanced by floating
silk-net edging.

THE QUEEN'S DRESSMAKER

Although Norman Hartnell had many devoted clients, none was more remarkable than Her Majesty Queen Elizabeth, who was the Duchess of York when they met in 1935. She became a member of the Royal Family in 1923 on her marriage to Prince Albert, the second son of King George V and Queen Mary. The "Smiling Duchess," as the popular press called her, briefly wore elegant clothes by Jeanne Lanvin in the 1920s, but was otherwise dressed by the sedate House of Handley Seymour, the grandest of the older Court dressmakers.

When King George V died in January 1936, the Queen commanded Hartnell (who had dressed her daughters for the royal wedding in 1935) to design black dresses for Court mourning. She did not know then that her brother-in-law, King Edward VIII, would abdicate to marry Wallis Simpson, an American divorcée, and that she would become Queen Consort the following May. Although the future Queen entrusted her Coronation dress to Madame Handley Seymour, Hartnell designed those of her Maids of Honour and soon became her sole dressmaker.

Because of the damage done to the monarchy and Mrs. Simpson's status as a fashion leader, King George VI was determined that the Queen should have a new regal image. He had definite ideas and with the Queen took Hartnell on a tour of the Royal Collection, showing Franz Xavier Winterhalter portraits of Empress Eugénie of France and Empress Elizabeth of Austria, which he thought would inspire the designer. "His Majesty made it clear in his quiet way that I should attempt to capture this picturesque grace in the dresses I was to design for the Queen," he wrote. "Thus it is to the King and Winterhalter that are owed the fine praises I later received for the regal renaissance of the romantic crinoline."

The Queen was so delighted with the first dress Hartnell designed for the Royal Family for the 1937 State Visit of the King of the Belgians—"a *robe de style* of gleaming silver tissue over a hooped *carcasse* of stiffened silver gauze with a deep *berthe* collar of silver lace encrusted with glittering diamonds," Hartnell wrote—that she asked him to design her entire wardrobe for the politically important 1938 State Visit to France. Hartnell relished "the task of designing some thirty dresses, grand dresses to be worn from morning to midnight under the most critical eyes in the world." His challenge included choosing colors that would complement the sealing-wax red of the Grand Cordon of the Légion d'Honneur that the Queen would be wearing in Paris.

Hartnell gave the Queen a startling new image. Apart from grand crinolines, he devised a slimmer, uncluttered silhouette with coordinating hats, gloves, bags, and shoes. Her coats were usually designed without buttons or visible fastenings to be worn over fitted dresses, sometimes with embroidery or detailed work in the fabric. Hats had upswept brims around closely fitted crowns that made her look taller. Verticality was a major part of the new style, and included shoes with higher heels.

The Queen embraced this new look and, with amendments, accepted all of Hartnell's designs for France. Then tragedy struck. The Queen's mother, the Countess of Strathmore, died, and the Court went into mourning. Though reluctant to cancel her trip to France, she could not appear in the colors Hartnell had used nor did she want to visit France in black, which would not convey the right mood for a trip meant to celebrate the two nations' unity and friendship at a time when Adolf Hitler was menacing the peace of Europe. Hartnell discovered that there were precedents for wearing white during Royal Mourning, which the Queen thought appropriate. Hartnell's workforce quickly remade the entire wardrobe. "Silks, satins, velvet, cloth, taffeta, tulle, chiffon, and lace were all to be in white," he wrote.

The success of the Queen's wardrobe cemented her relationship with Hartnell, who continued to create dresses for her until his death in 1979. The 1938 trip made a lasting impression on the French, including the great couturier Christian Dior. "Whenever I try to think of something particularly beautiful," he said once on a visit to London, "I think always of those lovely dresses that Mr. Hartnell made for your beautiful Queen when she visited Paris."

RIGHT His Majesty King George VI, far right, and Queen Elizabeth with Their Royal Highnesses Princesses Elizabeth and Margaret Rose were photographed at the Palace of Holyroodhouse in Scotland in July 1937, inspecting the Royal Company of Archers. The Queen wears a slim-line Hartnell design enhanced by the shaped fur of the cape that forms a dramatic contrast to the simplicity of the long dress. The visibility of her face and easily controlled structure of the clothes display two important facets of designing for royal ladies: gloved hands, and unrestricted movement of the arms. The creation of a background for impressive jewels is another aspect of dress considered in the design.

SATURDAY, JULY 23, 1938

DAILY SKE

ield of 20 years ago the King, accompanied by the Queen and President Lebrun, performed the last ceremony of his State visit—the unveiling of the impressive mem

ABOVE High visibility in a crowd is exemplified by one of the designs in the famous all-white wardrobe Hartnell created for the Queen when she accompanied the King on the State Visit to France in July of 1938. In mourning for the death of her mother, the Countess of Strathmore, the Queen was reminded by Hartnell that white is a prerogative of Royal Mourning. Within a few weeks, Hartnell's workforce replaced the colorful wardrobe that had just been made with a new white collection, and the State Visit to France went on to great acclaim at a crucial moment in history.

OPPOSITE In the summer of 1939, the Queen wore a slim-line Hartnell design at a garden party at a private house in Regents Park, London. The ensemble featured trailing leaf and flower embroidery on the bodice and one side of the front of the long day

dress, with motifs applied to the puffed-sleeve bolero and matching hat, the whole embellished with a regal ostrich feather boa.

OVERLEAF Varied sketches offer a glimpse of the Hartnell years and seasons of Queen Elizabeth's daytime ensembles from 1936 to 1956. One of the earliest black ensembles dates from 1935–36, bottom row far right, and another from the early 1940s, top row third from left. (Black is worn for a royal death and events surrounding Armistice Day in November.) The caped ensemble, top row far left, was worn for the service before the opening of the Festival of Britain in 1951 and on a visit to Dublin, Northern Ireland. The ensemble, far right, typifies the side-draped dresses and loose coats Queen Elizabeth wore from the late 1940s to the 1960s.

Specially designed for
H. M. THE QUEEN

Specially designed for
HER ROYAL HIGHNESS THE DUCHESS OF YORK

Norman Hartnell

Specially designed for:
H. M. THE QUEEN

ABOVE The first postwar Royal Tour of 1947 was to South Africa and Rhodesia. Hartnell was commanded to create extensive wardrobes for the Queen, Princess Elizabeth, and Princess Margaret. He refashioned his 1938 Paris crinolined garden party dress design for the Queen with greater emphasis on the neckline and horizontal banding. Ostrich feathers in the Queen's hat promoted a native South African product.

ABOVE RIGHT At Bagatelle in 1938, the Queen caused a sensation in her new crinoline fine lace afternoon dress. Hartnell's design made the numerous short-skirted French guests seem démodé, and her use of the parasol added to the effect, as an audible gasp was heard when she raised it.

OPPOSITE This famous 1939 photograph of Queen Elizabeth in Buckingham Palace by Cecil Beaton poignantly captured Britain's last summer of peace. The spangled three-tiered crinoline dress depended on the artistry of the Hartnell dressmakers in constructing boned underpinnings and underskirts with stiffened materials in order to retain the body of the fabric and to create a slight sway when the Queen moved. The crinoline was adapted by the leading designers in varying forms for evening wear at the time. Beaton's images of the Queen wearing Hartnell clothes were important in defining her strong new image, a combination of majesty and glamorous elegance.

DAILY SKETCH

No. 9,114 WEDNESDAY, JULY 20, 1938 ONE PENNY

...nly pleased by the great welcome to them——the King and Queen, with President Lebrun, in Paris. The State visit finds

La reine et le Président de la République, suivis du roi, de Mlle Lebrun et de M. Daladier, arrivent à 10 h. 15 sur le quai de la gare des Invalides.

(LIRE NOTRE COMPTE RENDU COMPLET EN PAGES 3, 4 et 5)
(VOIR LA SUITE DE NOTRE REPORTAGE PHOTOGRAPHIQUE EN PAGES 9 et 16)

NEW YORK
Herald Tribune

PARIS, THURSDAY, JULY 21, 1938

SAILINGS to NEW YORK
Pres. Harding... July 21 Aug. 18
Manhattan July 28 Aug. 25
Pres. Roosevelt Aug. 4 Sept. 1
Washington ... Aug. 11 Sept. 8
UNITED STATES LINES

In France, 1 fr. 25 c.

Round of Festivities Keeps King and Queen Busy From Laying Wreath at Tomb of Unknown Soldier In Morning to Opera Gala Lasting Past Midnight

Royal Guests Attending Garden Party at Bagatelle

Sovereigns Head Colorful River Procession From Quai d'Orsay to Hôtel de Ville, Hosts to British at Luncheon, Guests at Bagatelle, Entertain Lebruns at Dinner

The second day of the Paris visit of King George and Queen Elisabeth was filled from early morning until after midnight yesterday by a crowded program of official ceremonies and social functions.

The events of the day began at 9:45 a.m. with the King laying a wreath of English roses on the Tomb of the Unknown Soldier beneath the Arc de Triomphe.

Returning to the Ministry of Foreign Affairs after the brief ceremony, the King joined the Queen, and the two were escorted by boat along the Seine to the Hôtel de Ville, where they were received by the municipal authorities shortly before 11 a.m.

Visit Louvre to See British Exposition

After this ceremony, they went back to the Quai d'Orsay, starting out again at 1:30 p.m. for the British Embassy, where they lunched and received the members of the British colony.

Two hours later, they paid a brief visit to the Louvre to view the exposition of English painting, and from the Louvre they were driven directly to Bagatelle for a garden-party given in their honor.

At the termination of the garden-party, they returned to the Foreign Ministry for a short rest, then left at 8 p.m. for the British Embassy, where they were hosts at dinner for the President of the Republic and Mme Lebrun.

The dinner finished, the royal party drove for the first time through the sumptuously-decorated Boulevard de la Madeleine to the Opera at 10 p.m. to attend a gala of opera and ballet.

Huge Crowds Along Street Acclaim Royal Visitors

Queen Elisabeth in the picturesque setting of Bagatelle chatting with President Albert Lebrun and meeting the guests at the garden-party given in her honor and that of King George. The King is seen here-handed among the guests to the left.—Associated Press Photo.

PARIS TAKES OUR KING AND QUEEN TO ITS HEART

THURSDAY, JULY 21, 1938

Daily Mirror

No. 10803 Registered at the G.P.O. as a Newsp

SHE IS QUEEN OF TWO NATIONS

IT WAS THE QUEEN'S DAY IN PARIS YESTERDAY.

As she smilingly accepted the homage of France, her gracious manner and her regal beauty drew from one French diplomat the remark:—

"To-day France is a monarchy again. We have taken your Queen to our hearts. From now on she rules over two nations."

You see her, on the right, hesitating for a second as she searches for an elusive French word at the Garden Party in the grounds of the Chateau Bagatelle.

And you see her below, a Queen, but still a wife, looking anxiously to the still convalescent King who clearly enjoys the garden party cabaret.

✦ ✦ ✦

The loveliest picture of the Queen ever taken—see page 15.

The Queen will wear these in Paris...

POINTS

☆ The Queen's Paris dresses are mostly black or white.

☆ She is taking at least three white lace day and evening frocks.

☆ All her evening frocks have full skirts; two are actual crinolines.

☆ White roses, jasmine, lilies of the valley, camellias and parma violets are the flowers she has chosen as trimmings.

☆ The new fashion for embroidery appears on many of the dresses—diamante or silver stitching as well as broderie Anglaise.

White crepe and white fox

White crêpe frock and short coat. The frock has a centre seam and slightly draped side panel in the skirt. The waist is fitting, the neck soft and draped. Short simple coat has big cuffs of white fox...

White satin crinoline

A crinoline gown of white duchess satin panniered with draped bands of satin flounced with silver lace. The lace is closely embroidered with diamonds and silver paillettes. The Victorian off-the-shoulder neckline is also trimmed with a band of silver lace. Clusters of white camellias are strewn here and there about the skirt. The Queen may wear the Order of the Garter with this dress.

drawn

Queen Elizabeth Likes Lace

By FRANCES MANGUM.

While Queen Elizabeth of England is certainly no "style setter" in the manner of her in-laws, the Duchesses of Kent and Windsor, she none the less surprised Parisians last week with the wardrobe she selected especially for her visit to the French capital.

The crowning glory of the collection, designed, incidentally, by London's Norman Hartnell, was the Pompadour crinoline dress (sketched right), of silver lace mounted on tulle, which she wore to the elaborate dinner at President LeBrun's palace. The many, many yards of lace in the skirt were re-embroidered with diamante parlettes, and the bertha drop shoulder cape and hem were bordered with embroidered tulle.

The lines of the dress were especially flattering to the Queen, who, inclined to plumpness, needs either straight up and down lines that give a slenderizing effect, or else full bouffant effects for camouflage.

Beautiful Shoulders.

When Hartnell designed this dress he stressed the dropped corsage because the Queen has a lovely neck and beautiful shoulders, which should be emphasized whenever possible, he believes.

"I have no patience," declared Mr. Hartnell, "with women who always conceal their good features. If one has a lovely throat, then, by Jove, let her wear low necks, and if her hips are slender and waist sylph-like, then it's up to her to let her clothes stress them."

He further says that, in his humble opinion, a woman can, by emphasizing one good point, distract attention from her less attractive features.

Concealing a Thick Waist.

"For instance," he continued, "if one of my clients should have, say, an especially well-formed bosom, but a thick waist, do you know what scheme I'd follow in designing her clothes? I'd play up low necks, yokes, and the like, and I'd conceal the bad waist by using diagonal and vertical lines whenever possible, and full skirts to make the waist smaller by contrast."

But as to the Queen and her wardrobe, Mr. Hartnell says she is particularly fond of furs and lace and pastel colors. He uses a lot of fox, in white, beige and gray on her coats and jackets, he said, designs many lace dresses for her, and uses lace trim a lot.

For a luncheon one noon at the Hotel de Ville in Paris, she wore a long-skirted dress of white lace with a short-belted coat trimmed with white violets. Her matching small straw hat was half hidden under an ostrich plume.

Preference for Lace.

Again indicating her preference for lace, she selected for an afternoon garden party at Bagatelle a crisp white lace dress of the winter-halter type, with pleated horizontal lines. Her large hat and parasol were of pleated lace to match the dress.

The frock she chose for the grand opera was white satin with panniers of silver lace embroidered with diamond parlettes. Three festoons of silver lace adorned the skirt, and a band of the lace ornamented the puff sleeves.

There was a time when a lace dress was always thought of as "dressy," but during the last year or two lace has, in many instances, gone tailored. Many very simple little afternoon frocks are made of lace, and there are lace suits that look as though they were made of woven fabrics.

In Queen Elizabeth's wardrobe chosen for her recent trip to Paris there were many lace gowns.

One of the most outstanding (sketched at left) was a full-skirted off-shoulder white lace embroidered with silver.

A Queen's Version of The Crinoline Gown

Because this gown has been reflected as one of the most beautiful worn by Queen Elizabeth on her recent Paris visit, and because it shows many of the details used by Paris designers in the present openings, such as the wide band of embroidery and the extremely full skirt silhouette, it is illustrated today. The gown was omitted from the original group of sketches of the British sovereign's wardrobe, published in Women's Wear Daily July 27. Worn for the Versailles luncheon the frock is of white organza, entirely hand-embroidered in broderie anglaise design. The full skirt is further decorated with white organza flowers, the petals edged with the same hand-embroidery, graduating to delicately scalloped 'hem. The high waist line is slotted with black velvet, the ends of which flow to the ground. A large crinoline hat is banded with black velvet.

The King and Queen leaving the Quai d'Orsay Palace, to call on President Lebrun at the Elysée.

THE QUEEN AND THE DUCHESS IN CRINOLINES

Arriving at the Legation . . . the Queen is a crinoline gown of silver-grey satin, with large motifs of pearl-grey stars and diamonds, and wearing a circlet of diamonds with the Koh-i-noor on her hair.
Behind her, the King shakes hands.

Evening Standard
47 Shoe Lane, E.C.4.
Cutting from issue dated............ 2 2 JUL 1938

ROYAL DRESSES

THE beauty of the dresses worn by the Queen during her State visit to Paris has been widely commented on. All were designed and made for her Majesty by Norman Hartnell, 26, Bruton-street.

In the centre is the crinoline dress of white satin worn by the Queen for the gala performance at the Opera. Clusters of camellias hold the festooned draperies, edged with silver lace on the skirt. The dress on the right, of matt white crêpe romaine, has a matching coat bordered with white fox.

Fine white Nottingham lace was used for the dress on the left. This has a billowing skirt, and, as you see, a bolero of white lace edged with tulle. Her Majesty wore it with a large capeline hat at the garden party at Bagatelle.

Specially designed for

HER MAJESTY THE QUEEN

Specially designed for

H. M. THE QUEEN

PREVIOUS PAGES The State Visit to France in July of 1938 was politically vital. War with Germany seemed imminent and the Anglo-French Alliance had to be reinforced. The Queen's wardrobe was designed to include ingenious ensembles featuring the new crinoline silhouette. The death of the Queen's mother meant that the delicately hued clothes had to be remade a few weeks later, in keeping with Royal Mourning.

ABOVE LEFT AND ABOVE Drawings of the 1940s show designs for two elegant crinoline gowns created for the Queen: On the left, a heavily pleated full skirt beneath a nipped waist and an embroidered neckline; on the right, the semi-crinoline worn after the war, here embellished with the diamond-drop jewel seen in the Beaton portrait, opposite, a typical Hartnell touch.

OPPOSITE The Queen was photographed by Beaton wearing a gown designed for the portrait session in 1948 marking the Silver Jubilee of her marriage to King George VI. The enduring power of the image underlines the physical attributes of the Queen, who was known for her dark hair worn in a chignon, the pink and white of her flawless complexion, and her blue eyes. Hartnell and Beaton enjoyed a rare moment of friendly collaboration in their fraught professional relationship. The dress was later worn for an evening reception at the Victoria & Albert Museum in London.

PREVIOUS PAGES Visibility in a crowd is illustrated as the Royal Family sat among the crew of HMS *Vanguard* during the sea voyage to their Royal Tour of South Africa in 1947, for which Hartnell designed extensive wardrobes for the Queen and the Princesses Elizabeth and Margaret Rose. The Royal Ladies received government sanction for extra clothing allowances for their official duties at a time when Britain suffered the years of Austerity and a bitter winter. The King had to be dissuaded from turning back to be with his people. Hartnell's workload was such that some of the Princesses' clothes were designed by Edward Molyneux at his London salon.

OPPOSITE Arriving with King George VI and the Princesses in Salisbury, Southern Rhodesia, during the Royal Tour of 1947, the Queen wears a dusty hydrangea-pink day ensemble. The side-pleated skirt with a tie waist and low neckline under a loose coat with padded shoulders features open-work detailing on the sleeves. The neat hat with an upswept feather-trimmed brim was a style refashioned for her in the following decades. The Princesses wear fashionable dresses of the period with simple brimmed hats.

RIGHT Although not strictly adhering to any current fashion, the elegant style of the Queen during the 1940s and early 1950s was worn in modified form by other women in Britain. This design dates from 1954.

ABOVE For the State Opening of Parliament in Cape Town, South Africa, in 1947, Hartnell created a slim-line day dress reminiscent of his most sophisticated 1930s designs. Enhanced with subtle embroidery, the status of the Queen was underlined by the embroidered train, dividing from the shoulders and allowing her to sit without creasing it.

OPPOSITE For the photographic portrait marking the Silver Jubilee of their marriage in 1948, King George VI and Queen Elizabeth stand amidst the Imperial pomp of the Throne Room at Buckingham Palace. The Queen's lavishly embroidered dress featured the lowered crinoline, forming the lowest section of the dress, a technical feat of some skill.

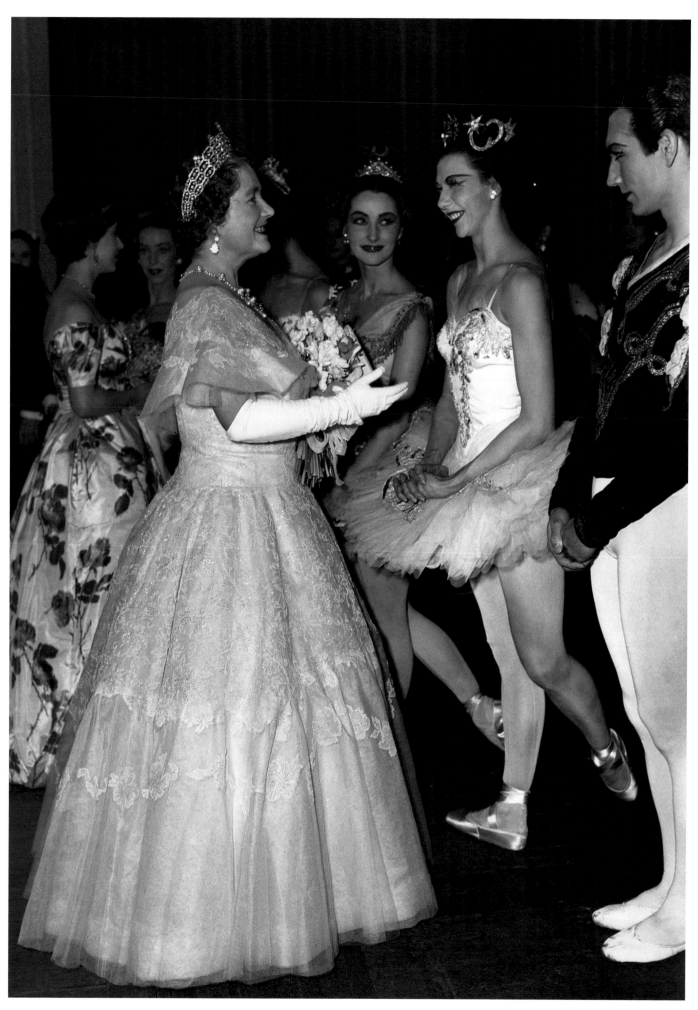

LEFT Queen Elizabeth greets members of the Royal Ballet backstage around 1950. The Hartnell crinoline evolved into a stylized form of royal dress, softly imposing and worked with fine embroidery, the shape suddenly fashionable for women's evening dresses around the world, as Christian Dior and other Paris designers utilized the idea after 1947.

OPPOSITE LEFT A sketch shows the Hartnell design for the embroidered dress worn by Queen Elizabeth when she accompanied King George VI to the State Opening of Parliament in Cape Town during the Royal Tour of 1947. An outline would be drawn for the pattern of the embroidery, and a selection of beads, sequins, and brilliants placed on it in varying combinations until the desired effect was achieved. The embroidery workroom could then take over.

OPPOSITE RIGHT The combination of ruching and draping, the caped sleeves, and the trailing tiered skirt typify the late 1940s. The design was one of many variations to be shown to the Queen for a State Occasion, as the wearing of the ribbon of the Order of the Garter indicates. Hartnell included some of the Queen's favorite jewels, such as the pearls, tiara, and fringed diamond clasp.

specially designed for Norman

H. M. THE QUEEN

Norman Hartnell

specially designed for

H. M. THE QUEEN

ABOVE AND ABOVE RIGHT The formula evolved by Hartnell in the mid-1930s for the future Queen Elizabeth was capable of fashionable variety. Two sketches for day ensembles from the late 1940s depict the ingredients to perfection: a loose coat over a fitted skirt, the use of fur to add decorative detail at difficult points of the figure, and—also included in the design to personalize the effect—the jewels often worn by the Queen in public.

OPPOSITE A major feature of all Hartnell designs for Queen Elizabeth was the wide variety of hats intended to harmonize the overall look. All the hats had to withstand the often testing surroundings of royal engagements, such as this cockaded version, worn on a visit to a military event. Hats were made in-house until the 1950s.

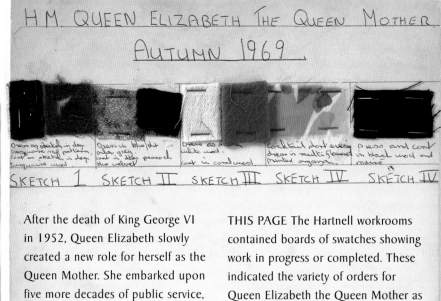

After the death of King George VI in 1952, Queen Elizabeth slowly created a new role for herself as the Queen Mother. She embarked upon five more decades of public service, undertaking a ceaseless round of engagements which augmented those of her daughter Queen Elizabeth II and other members of the Royal Family. Engagements required new clothes from Hartnell, who was always able to design collections each season for both individual clients and for the ladies of the Royal Family.

THIS PAGE The Hartnell workrooms contained boards of swatches showing work in progress or completed. These indicated the variety of orders for Queen Elizabeth the Queen Mother as she approached her seventieth birthday.

OPPOSITE Photographed in 1970 in the gardens of her country house, Royal Lodge, Windsor, the Queen Mother wears one of her simple summer Hartnell dresses.

WARTIME

When World War II started on September 3, 1939, Norman Hartnell was at his country home, Lovel Dene, in Windsor Forest. He hurried back to London, and when he reported to the War Office he was rejected as being too old for combat. He joined the Home Guard and was of service to his country during the war, maintaining his couture house for the benefit of the country's export drive, and to produce rationed clothes.

One of the challenges of being a fashion designer in wartime England was having to observe government restrictions. "To these limitations in dress, which stipulated how much material, how many seams a dress could comprise, how much adornment and how wide the collar or belt of a dress might be," Hartnell recalled, "the Queen adhered strictly." For one dress, he "painted by hand garlands of wax-like lilac and glossy green leaves on a voluminous gown of white satin, with which Her Majesty wore ornaments of diamonds and rubies."

When Hartnell was asked by Berkertex, a leading dress manufacturer, to design "Utility" dresses for the mass market, he worried that he might compromise his relationship with the Queen, as he held a warrant as dressmaker "By Appointment to Her Majesty the Queen." The Board of Trade urged him to cooperate, because it believed that a designer of his stature would help popularize Utility styles with ordinary women. Unsure, he asked the Queen for advice. "You have made so many charming things for me," she told him, "that if you can do likewise for my countrywomen, I think it would be an excellent thing to do."

Both the Allies and the Axis powers courted the South American countries during the war. Hartnell created an Export Collection for both North and South America. The London wives of South American diplomats were able to dress at Hartnell and by 1943 devised with him an exhibition of miniature versions of authentic costumes from twenty Latin American countries that would tour Great Britain. The exhibition would not only introduce Britons to the beauty of Latin American culture but would also raise funds for an important charity, the Soldiers', Sailors' and Airmen's Families Association. Because of restrictions, Hartnell could not buy wood to mount the exhibit, so he took apart a partition in his own kitchen to

make the struts to hold the plinths. For the costumes themselves, Hartnell recycled prewar remnants and patterns from his workrooms.

When the Queen came to view the exhibit, he pointed out that the Nicaraguan figure was dressed in a "somewhat ordinary" small cherry-and-white printed brocade that expressed "the unobtrusive character of the peasant like figure," Hartnell recalled in his autobiography. The Queen, apparently, was not offended. "Indeed!" said Her Majesty. "I see you used a piece of my last year's evening wrap to do so."

Soon after the war began, Hartnell organized the other leading London couturiers to establish the Incorporated Society of London Fashion Designers (the equivalent of the French Chambre Syndicale), dedicated to promoting British fashion. Depending on how many members there were at any given moment, the group was later known in the press as the "Top Ten," "First Eleven," or "Dressmaker's Dozen." While continuing to serve its clientele, the group also contributed to the war effort, and Hartnell and his rivals Edward Molyneux and Charles Creed were all asked to design a uniform for the Women's Royal Army Corps (WRAC). Hartnell's design—a simple skirt and tunic—was chosen by the King, although he requested that Hartnell change the color combination to steel grey and scarlet because the uniform would be worn by Queen Alexandra's Royal Army Nursing Corps, and these were their colors. This design was also chosen for the Colonel in Chief of the WRAC, Her Royal Highness the Princess Royal, the King's sister.

RIGHT Models stroll down London's New Bond Street. They wear Hartnell's 1942 Utility dresses, created by the designer in response to government restrictions on the amount of materials allowed in producing new clothes. Berkertex, a modern factory, turned out attractive and affordable dresses, making Hartnell the first great couturier to design ready-to-wear clothing, an activity encouraged by the Queen.

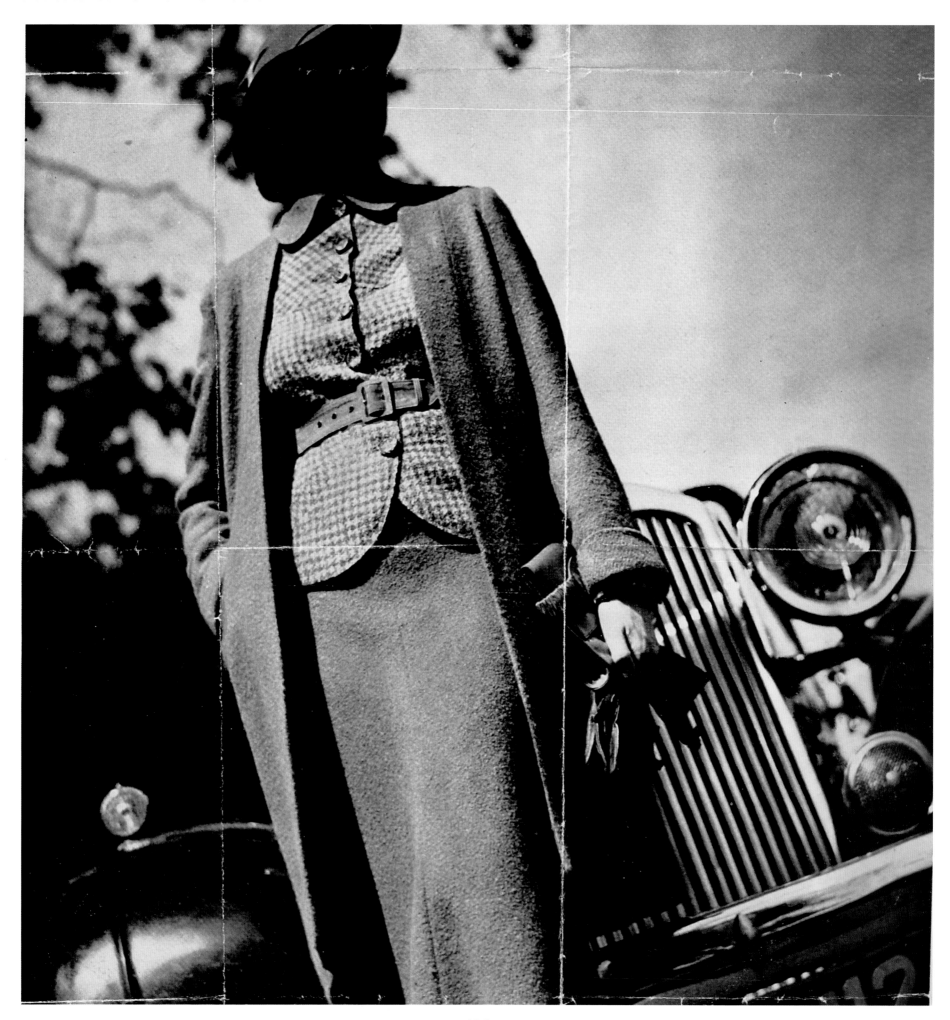

OPPOSITE The 1940 Hartnell look created during the Phoney War, as it was known in Britain (the period when nothing seemed to happen in the war from the German invasion of Poland in September 1939 to the June 1940 invasion of France), included an autumn/winter ensemble of a loose three-quarter woolen coat over a matching skirt and contrasting fitted plaid jacket.

RIGHT A wartime outfit with a shorter skirt, a fitted short-sleeved jacket, a cut-away front, and contrasting fabric details is from the 1940 Summer Export Collection promoted in the United States. The platform shoes were an extreme version of a style fashionable in the late 1930s, but made with cork or wooden soles and a minimum of rationed leather. The design is balanced by a frivolous picture hat.

ABOVE Created for export to gain foreign currency as well as favorable publicity, a special collection of beaded gowns was shown to Turkish journalists and diplomats under the auspices of the Ministry of Information. Tens of thousands of beads remained in stock, but their use was limited according to the working hours and materials allowed by government regulations.

ABOVE This silk crêpe embroidered sheath, the forerunner of the design worn by the Queen in South Africa in 1947 for the State Opening of Parliament, epitomized the Hartnell elegance of the 1940s. It was shown on Dorothy Stephensen, renamed Dolores by Hartnell after the renowned model used by the Expressionist sculptor Jacob Epstein in the 1920s. Dolores was to remain with the designer for over three decades.

ABOVE This 1940s development of Hartnell's late 1930s taste for elaborate embroideries on delicate fabrics was part of an Export Collection aimed at the Turkish and Middle Eastern markets. Designers received extra allocations of materials to counteract the Austro-German and French Vichy government designs seen in various publications such as *Signal*, with its multi-language editions.

ABOVE From the 1942 Export Collection, this bias-cut heavily beaded and sequined silk crêpe evening ensemble was made for sale to clients in Turkey and the Middle East.

*Below: Air Force blue woollen, fullness
set in front by graduated box pleats.
Trouser dress in silver grey woollen
under a bark brown fitted topcoat.*

BUSINESS
AS USUAL

EVA LUTYENS

STIEBEL

HARTNELL

*Gaiety in dinner dresses·
rose-red crepe with the red roses
of England pinned on the bodice.*

17

OPPOSITE The slim, fitted sheath dress, often with a front or side opening, remained as an alternative to the crinoline, as seen in this magazine article of the period. This silhouette could be adorned with any type of detailing, as in this wartime evening dress with padded shoulders and a high waist, far left. Embroidery, pleats, and tucks were all possible within the capacity of the client's coupon allowance and her budget. The style continued throughout the era and well into the postwar period of Austerity, as rationing only ended in 1953.

RIGHT Sketches of Hartnell designs from 1939 to 1945 include a black 1940s Austerity-regulated day ensemble in the mood of the wartime clothes designed for the Queen, bottom row left, and an outfit for Lady Wavell, wife of the distinguished Field Marshall and Vice-Reine of India, top row right. The ingenuity of design inherent in the slender allowance of materials is apparent.

LEFT One of Hartnell's numerous designs for the Queen during the war was shown in one of the dusty pastel shades for which she was famous. Soft tones created an uplifting effect on morale needed during usually arduous public appearances in war-torn areas of Britain. Lilac, hydrangea blue, and pink were sometimes alternated with darker colors. The locations were often dusty, but only black and green were deemed taboo. This ensemble utilizes the Hartnell technique of balancing fur at the cuffs and adding a clutch bag to offset the fuller figure of the Queen, as already seen in Hartnell's earlier 1930s designs.

OPPOSITE The Hartnell look in action as worn by Queen Elizabeth in 1940 in East London, with a loose-fitting coat balanced by a typical high-brimmed hat that lent height to her small stature—as did the high-heeled shoes. Off-the-face hats were a necessity, as they gave full visibility to the crowds. Royal walkabouts began in Canada in 1939 and contributed to the comfort displayed to the British people during grueling events.

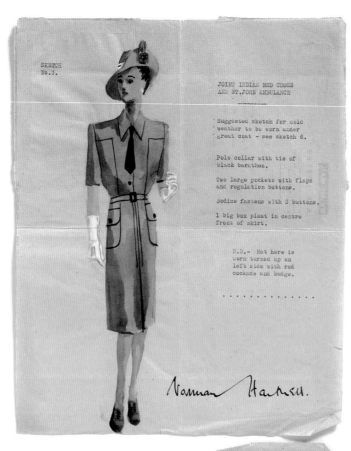

SKETCH
No.3.

JOINT INDIAN RED CROSS
AND ST.JOHN AMBULANCE

Suggested sketch for cold
weather to be worn under
great coat - see sketch 6.

Polo collar with tie of
black barathea.

Two large pockets with flaps
and regulation buttons.

Bodice fastens with 3 buttons.

1 big box pleat in centre
front of skirt.

N.B.- Hat here is
worn turned up on
left side with red
cockade and badge.

.

Norman Hartnell.

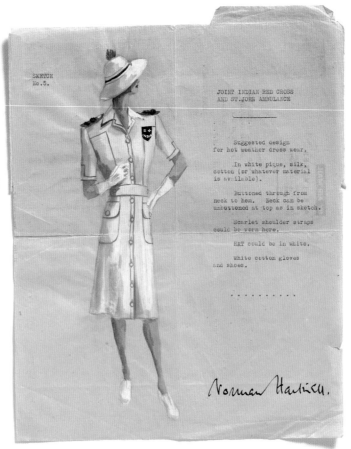

SKETCH
No.5.

JOINT INDIAN RED CROSS
AND ST.JOHN AMBULANCE

Suggested design
for hot weather dress wear.

In white pique, silk,
cotton (or whatever material
is available).

Buttoned through from
neck to hem. Neck can be
unbuttoned at top as in sketch.

Scarlet shoulder straps
could be worn here.

HAT could be in white.

White cotton gloves
and shoes.

.

Norman Hartnell.

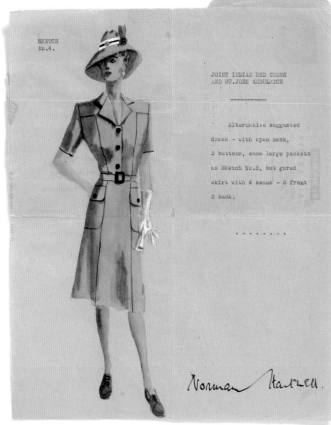

SKETCH
No.4.

JOINT INDIAN RED CROSS
AND ST.JOHN AMBULANCE

Alternative suggested
dress - with open neck,
3 buttons, same large pockets
as Sketch No.3, but gored
skirt with 4 seams - 2 front
2 back.

.

Norman Hartnell.

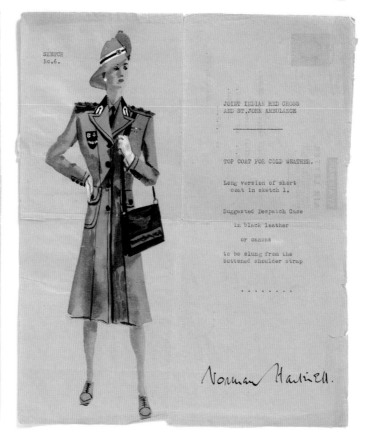

SKETCH
No.6.

JOINT INDIAN RED CROSS
AND ST.JOHN AMBULANCE

TOP COAT FOR COLD WEATHER.

Long version of short
coat in sketch 1.

Suggested Despatch Case

in black leather

or canvas

to be slung from the
buttoned shoulder strap

.

Norman Hartnell.

OPPOSITE Sketches show Hartnell's designs for the Combined Indian Red Cross and St. John's Ambulance Brigade of 1943. Soon after the formation of the Incorporated Society of London Fashion Designers in 1942, Hartnell, Molyneux, and Creed were asked to submit designs for the Women's Royal Army Corps uniforms. Hartnell's won the competition and the designs were also used for the steel grey and scarlet uniforms of Queen Alexandra's Royal Army Nursing Corps.

RIGHT Other commissions for uniforms included those worn by members of the British Red Cross Society in the 1950s.

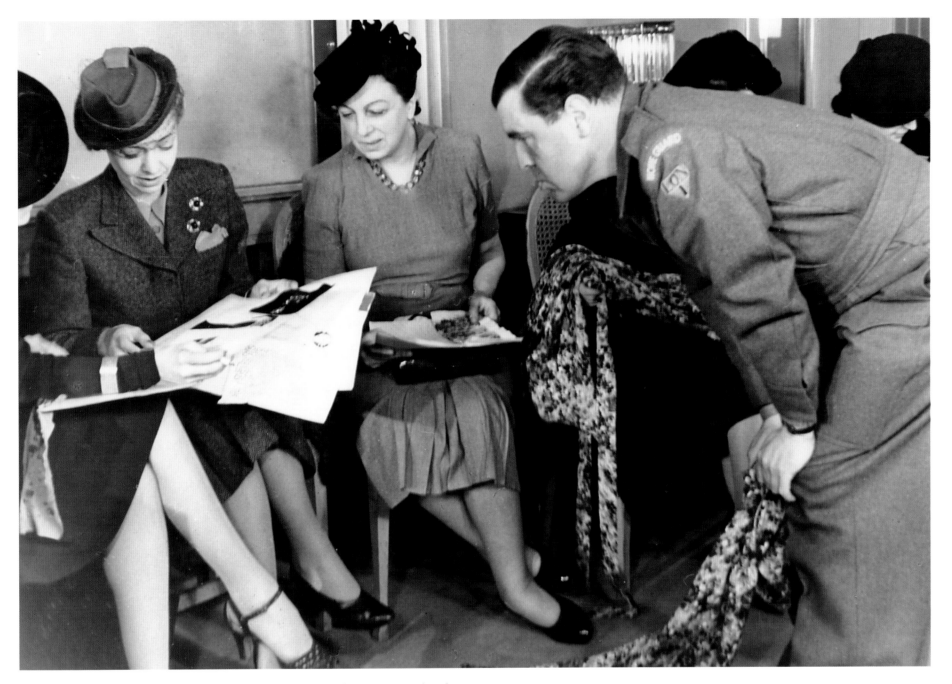

OPPOSITE In 1942, models display three Utility dresses by the Serpentine, in London's Hyde Park. A variety of designs, materials, and colors were available to women with the necessary coupons and cash. Made by Berkertex, the ready-to-wear dresses proved to be immensely popular, and every purchaser was able to share in the allure of the Hartnell name.

ABOVE Wearing the Home Guard uniform, Hartnell explained the merits of his Export Collection to ladies of the press and Turkish diplomatic corps at a 1942 show in the salon at 26 Bruton Street. Such collections were influential promotion tools and also earned vital foreign currency.

LEFT AND RIGHT Original Hartnell designs of shoes are in the height of 1940s fashion. Always ready to consider any aspect of women's dress, these were commissioned when his Utility designs were a national success. Stocks of leather and shoemaking materials were rationed, so Hartnell worked within government guidelines to create elegant shoes with sex appeal, including the squared-toe designs that became fashionable after the war.

LEFT By 1951, Hartnell's ready-to-wear clothes were sold in Paris department stores. Parisians could take the bus wearing a dress by the Queen of England's designer.

OPPOSITE The commercial successor to Utility clothing was postwar Austerity, exemplified by a Berkertex rayon print dress with its festive hints of the seaside. The narrow cuffs on the short sleeves and double row of buttons were emphasized by the belted waist and the slight fullness of the skirt.

LEFT A draped ivory satin crinoline dress of 1947 was decorated with painted flowers. This technique overcame the problems of rationing regulations during the Austerity period of 1945–1951.

OPPOSITE Leading lady Anna Neagle, with Michael Wilding in a film still from the musical 1949 *Maytime in Mayfair*, displayed to full advantage one of Hartnell's dresses, an extravagantly romantic design to be dreamed of in the period of England's Austerity, marking the end of the most severe restrictions. Hartnell began designing for British films in the late 1920s but turned down Hollywood offers, preferring to remain in London.

FROM PRINCESS TO QUEEN

Norman Hartnell first dressed Princess Elizabeth of York when she was nine years old, before it was known that she would become the ruling monarch. After her uncle David's (King Edward VIII) Abdication in 1937, she became Heir Apparent and the course of her life was irrevocably set. From 1945 until his death in 1979, Hartnell would be involved in virtually every important event of Her Majesty's life.

From his earliest designs for the Princess, Hartnell was clear. "The future Queen had less freedom of choice in what she wore than many of her subjects," fashion journalist Anne Edwards wrote. She had "the pressure to conform to upper-class formality combined with the pressure to dress with regal formality too." She followed her mother and grandmother's preference for pale pastel colors, which were thought to make them stand out in a crowd. "When Norman Hartnell dressed the whole family for Ascot, grouped in the Royal Box, they looked like a delicate bunch of sweet peas," Edwards observed.

In July 1947, the Palace informed Hartnell that the Princess would be marrying Lieutenant Philip Mountbatten, Royal Navy, in November. Hartnell was unsure of a forty-seven-year-old man being chosen as the designer of the dress of such a young woman, but the Queen commanded him to submit sketches for the wedding dress. "I roamed the London art galleries in search of classic inspiration," he recalled in his autobiography, "and, fortunately, found a Botticelli figure in clinging ivory silk, trailed with jasmine, smilax, syringa, and small white rose-like blossoms. I thought these flora might be interpreted on a modern dress through the medium of fine white crystals and pearls—if only I had the pearls." The pearls—all ten thousand of them—were imported from the United States and sewn onto a glossy background of English satin. Procuring the right satin for the wedding dress became a political problem, another example of the complicated nature of designing for royalty. The Queen had requested that the satin come

from Lullington Castle. It was lustrous and stiff and appropriate for the train but not for the dress itself. So Hartnell ordered satin from the Scottish firm of Winterthur, which caused an uproar. "I was told in confidence that certain circles were trying to stop the use of the Scottish satin on the grounds of patriotism," he recalled. "[T]he silk worms, they said, were Italian, and possibly even Japanese! Was I so guilty of treason that I would deliberately use *enemy* silk worms?" It turned out the silk worms were from Nationalist China, which eased his conscience.

The wedding dress and glamorous fifteen-foot-long train was a tour de force of dressmaking. As with his great pre-war wedding dresses, it enhanced the beauty of the bride, creating a magical aura around the Princess. "Her long embroidered train seemed at first to float behind her, but in walked two tiny creatures in Royal Stuart tartan kilts, Prince Michael of Kent on the left and Prince William of Gloucester on the right," reported the *New York Times*. James Laver, the eminent costume historian, thought that the dress was "as ethereal, complex, and romantic as a great piece of music. The occasion demanded a poet, and Mr. Hartnell has not failed to string his lyre with art and to ring in tune."

For day clothes, both Princess and designer were taxed by the Austerity government regulations concerning rationing. "Official" clothes were treated more leniently, as they were furthering the image of the State on public occasions. Yet there could be no Dior New Look for the Princess. Hartnell successfully created a new youthful image, similar to that of others in her age group, but subtly different.

RIGHT With Hartnell seated to her left, Princess Elizabeth views his current designs at the 1950 Scottish Industries Fair. Such commercial enterprises helped to boost British products in the difficult postwar years as Britain endured rationing.

LEFT AND OPPOSITE Her Royal Highness Princess Elizabeth was photographed by Cecil Beaton in March 1945, just before her nineteenth birthday. The images were not released until after VE Day—or Victory in Europe Day—on the 8th of May, when the Allies accepted the surrender of Nazi Germany. Hartnell altered two prewar dresses made for her mother, the Queen. Beaton considered that the pink butterfly-spangled crinoline, opposite, was equal to the romantic elegance displayed by the Queen in his famous photographs of 1939. The full-sleeved neoclassical design of the dress, left, captured the mood of fashion in 1945.

ABOVE Three designs of the late 1940s for Princess Elizabeth depict the emerging youthful style that came to typify her look.

OPPOSITE For the 1947 Royal Tour of South Africa and Rhodesia, Hartnell designed the wardrobes of all three Royal Ladies: the Queen, Princess Elizabeth, and Princess Margaret. The three varying designs all flattered one another—those of the Princesses being in the current fashion, while the Queen added individual touches to her own already established look.

OPPOSITE AND RIGHT When the forty-seven-year-old Hartnell submitted his designs for the wedding dress Princess Elizabeth would wear for her marriage to Prince Philip on November 20, 1947, in Westminster Abbey, he worried unnecessarily about dressing a young bride of twenty-one. The ivory duchesse-satin dress recalled his great prewar designs, but was completely original. The pronounced shoulder line and long sleeves offset the simple yoke neckline and the full skirt with its deep folds. Like the dress, the train was embroidered with thousands of seed pearls and crystal beads in garlands of star-shaped lily heads and white York roses with orange blossoms and ears of corn, all of which were highlighted by the tiara holding the rest of the veil.

LEFT The glamorous satin wedding dress worn by the Princess was framed by Hartnell's subtle designs for the brides-maids' dresses. The impressively regal cloth-of-gold-tissue dress worn by the Queen and the elegant dress of gold tissue embossed with dark turquoise cut-velvet worn by the Princess's grandmother Queen Mary, third from left, formed part of Hartnell's overall design for the major participants in the ceremony, which included the uniformed King George VI and other members of the Armed Forces during the day's ceremonies. In the varied settings in which it was seen, the dress held center stage and enhanced the beauty of the young bride, as intended by Hartnell.

LEFT Hartnell devised his own New Look in 1948 to fit the personalities of the two Princesses. Princess Margaret, far left, wears a fitted coat with distinctive tailoring seen in the darts and pleats of the full skirt. Princess Elizabeth's pale green coat displays the modified Edwardian revival of the period worn with platform shoes. Both princesses hold the same cloth handbags.

OPPOSITE A full-skirted dress of red velvet and matching black-lined stole, designed around 1948 for Princess Margaret. It typifies the fashionable semi-crinoline outline Hartnell had evolved from his prewar crinoline silhouette and was worn to good effect by both Royal Princesses in the 1940s.

specially designed for:

H·R·H· THE PRINCESS MARGARET Norman Hartnell

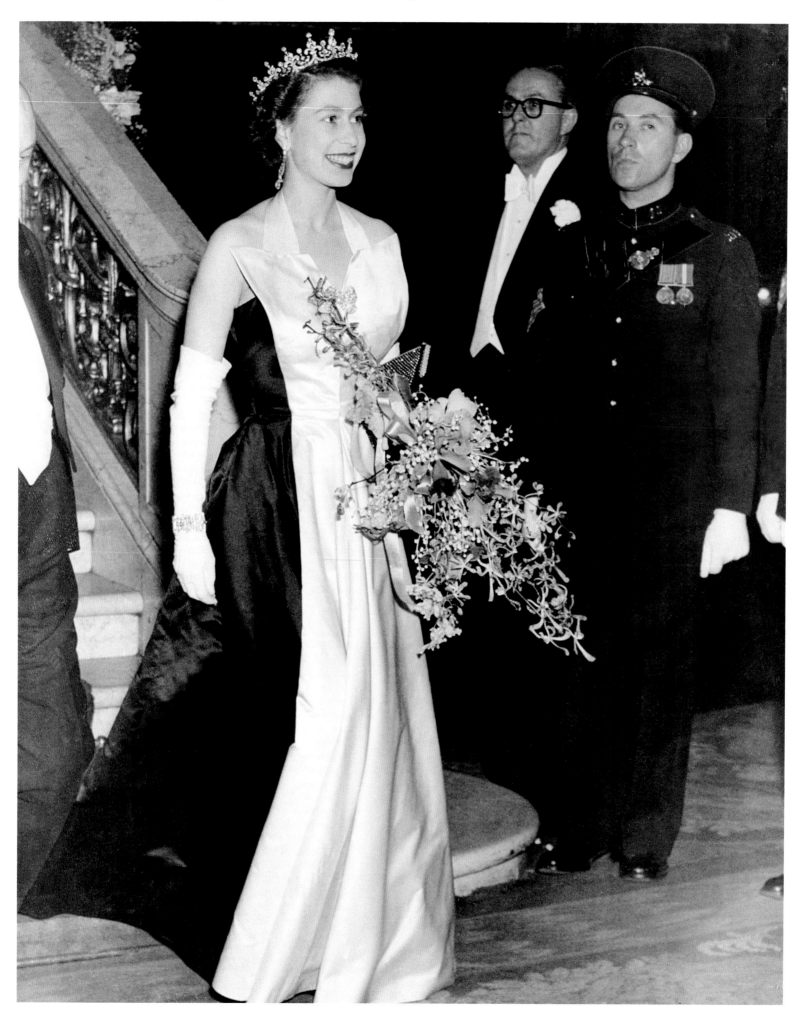

Upon the untimely death of her father, King George VI, in February 1952, Princess Elizabeth, Duchess of Edinburgh became Queen. Until her Coronation in June 1953, she carried out a multitude of engagements. Hartnell further developed his couture designs to create a more mature style in keeping with her status as Queen of the United Kingdom and Head of the Commonwealth.

OPPOSITE In late 1952, Hartnell's Magpie look in black-and-white satin was worn by the Queen for a royal film performance. The stunning dress was copied by dress manufacturers overnight and appeared in shops the following morning. From then on the Queen was usually seen in more elaborately detailed dresses.

RIGHT The twenty-six-year-old Queen was a beautiful young woman. Hartnell created this famous ruched taffeta, or cabbage-leaf dress, in 1952. It became famous through the portrait taken by Dorothy Wilding, a leading studio photographer in London from the 1920s to the 1960s.

OPPOSITE AND RIGHT Hartnell's early designs for the young Queen often included asymmetric necklines and embroidery, as in this full-skirted white satin evening dress, opposite, worn with impressive jewels. The lightly crinolined dress of embroidered lace over floating silk net, right, became the image of the Queen at the beginning of the new Elizabethan Era in England and the Commonwealth, as Great Britain emerged from the difficulties of the postwar years.

In this new portrait, taken in the drawing-room of Clarence House by Baron, the Princess wears a Hartnell tulle and lace ball dress worked with silver thread; her necklace is of sapphires and diamonds. One large diamond dominates her engagement ring, a Grecian heirloom of the Duke's family. The Duke is in lieutenant-commander's mess uniform with the Order of the Garter

SPECIAL "ILLUSTRATED" SOUVENIR

CORONATION COUTURE

The dress Norman Hartnell designed for Her Majesty Queen Elizabeth II's Coronation in Westminster Abbey on June 2, 1953, is one of the most famous and lavishly decorated dresses of the twentieth century. Visible during the televised ceremony and then in color newsreels and films around the world, it defined and transcended mid-century fashion. Clearly of its time, the dress alludes to historic costume and royal precedents. Hartnell made sure this romantic and glamorous masterpiece would complement the composed serenity of the young Queen's beauty.

Hartnell's enduring genius lay in his ability to create fabulous dresses that enhanced the wearer and amplified her character. The elaborate design of the embroideries might have detracted from the Queen herself, but the dress came to life as she moved, and the subtle folds of the skirt lent the dress its own momentum. Framed by the ermine-trimmed robes and the long embroidered train, the Queen was radiant. The effect was heightened by the bejeweled Orb and Scepter and the glittering Imperial State Crown.

Hartnell also had to consider what everyone else would be wearing to ensure that the Queen was always visually the center of attention. He considered the kaleidoscopic array of colors formed by the varied clothing and uniforms of those who would witness the crowning of the young Queen. He visited the London Museum and the London Library to learn what history and tradition dictated for a Coronation dress.

Retreating to Lovel Dene, his country house, Hartnell sketched different designs to present to the Queen. "My mind was teeming with heraldic and floral ideas," he recalled in his autobiography. "I thought of lilies, roses, marguerites and golden corn; I thought of altar clothes and sacred vestments; I thought of the sky, the earth, the sun, the moon, the stars and everything heavenly that might be embroidered upon a dress destined to be historic."

Of his many versions of the Coronation dress, nine were worked up into accomplished sketches by Ian Thomas, his new assistant. During the course of considering the sketches, which ranged from almost extreme simplicity to embroidered intricacy, the Queen commanded that the

design of the silhouette follow that of her 1947 wedding dress. She also agreed that color be included and asked for the use of the emblems of Great Britain, later insisting on the inclusion of all of the emblems of her dominions. The final sketch was accepted with one correction to the green of the Irish shamrock.

Hartnell further designed the white linen sunray-pleated dress fastened with large buttons, worn over the Coronation dress for the most sacred moment of the Coronation Service, the Annointing. Hartnell wrote that many thought the young Queen to be at her loveliest in this simple garment, which was removed by the Mistress of the Robes and replaced with the Colobium sindonis and golden Supertunica by the Dean of Westminster for the Presentation of the Regalia.

The coordinating dresses worn by the six Maids of Honour and those of Queen Elizabeth the Queen Mother, Princess Margaret, the Duchess of Kent, and her daughter Princess Alexandra, as well as Her Majesty's Ladies of the Bedchamber: the Countess of Euston and the Countess of Leicester were also by the designer. Hartnell could not allow this work to disrupt his regular business. He showed his Silver and Gold Summer Collection in the salon, knowing that it would be bought by clients from around the world attending the Coronation.

The months leading up to the Coronation were anxious, busy ones for Hartnell and his staff, but their efforts were appreciated by the Queen at her final fitting. "Although it is not etiquette for me to quote the exact terms of Her Majesty's verdict," Hartnell wrote of the day, "she did use the one word, 'Glorious.'"

RIGHT Even though Coronation Day, June 2, 1953, was wet and chilly, crowds gathered all night, and the colorful splendor of the processions, which culminated at Buckingham Palace, did not disappoint them. On the balcony, Queen Elizabeth II, Prince Philip, the Queen Mother, and Princess Margaret were joined by Prince Charles and Princess Anne, the six Maids of Honour, and other members of the Royal Family, creating a dazzling display of Hartnell magnificence.

ABOVE Bergdorf Goodman, the leading New York fashion store, showed part of Hartnell's Silver and Gold Collection of 1953 in a series of specially dressed windows, twenty-five years after Best & Company had also dedicated their windows to the designer.

RIGHT One of the gold dresses from the Silver and Gold Collection is worn with a red velvet jacket, third from right, among dresses designed by other London couturiers. The shimmering slim-lined beaded gown, second from right, offered a contrasting look. Due to the Coronation, the members of the Incorporated Society of London Fashion Designers attracted worldwide orders in 1953, and London couture was revitalized.

TRATED—December 6, 1952
28

Coronation Parade For The Queen

BRITAIN'S leading dress designers gave the Queen a glamorous preview of Coronation Year styles at Claridge's Hotel, London. From the actual position where the Queen was to appraise the gowns in the cream and gold ballroom, Russell Westwood took this exclusive ILLUSTRATED colour photograph of the models as they grouped in the Royal fashion parade.

1 Michael Sherrard's gown is in rich velvet, with a "portrait" neckline and a bertha collar designed specially to show off the jewels. Full folds of the skirt spring from a tightly nipped waist.

2 Digby Morton chooses layers of net and trims them with embroidered flounces. The front of the skirt is left plain; the back fans out in a peacock's tail of graduated tiers.

3 Victor Stiebel uses a pure silk taffeta embossed with circular velvet motifs for his crinoline-type ball gown. Hooped petticoats hold out the full skirt. One wide shoulder strap is draped diagonally from the left side over the right shoulder.

4 Mattli takes brocade and trims it with black fringing. The ends of the shawl neckline are knotted behind and fall to the ground in a small double train, or they can be looped over the arm in stole fashion.

5 Peter Russell favours the "covered up" look. The transparent bodice, high in the neck and long in the sleeves, is embroidered with beads and paillettes. The skirt is of tulle.

6 John Cavanagh likes the stiffness of grosgrain, with narrow camisole shoulder straps. The skirt cascades at the back carrying out the designer's swanlike theme.

7 Worth created this ball gown in duchess satin. The strapless bodice is boned and the skirt falls in deep folds to a wide hem. Crystal embroidery highlights the draping of the bodice and top of the skirt.

8 Mattli has another gown draped in Grecian style and made of black silk jersey. Over it is worn an opera cloak in poult.

9 Velvet is a royal material and is chosen by Peter Russell for this gown with its unusual figure-of-eight shoulder straps.

10 This Worth dress in poult has a strapless bodice covered by a little cutaway bolero with an Elizabethan collar. The skirt uses two shades of the material in panels.

11 Norman Hartnell has designed a dress in duchess satin with a velvet jacket. The skirt is starred with little beaded flowers.

12 This shimmering gown is another by Hartnell. A net fabric covered with sequins is used for this two-piece. The strapless dress is covered with a loose crossover jacket.

13 A rich brocade is used by Worth and to give it further richness there is bead embroidery. The fitted and boned bodice is finished with a softening frill.

LEFT The French Ambassadress Madame Massigli in the salon, as Hartnell explains the symbolism of the different embroideries on the Coronation dress, executed by Miss Edie Duley and the hands of the seamstresses in her extensive workroom. No other London house and few in Paris could match this work, a luxurious specialty that was akin to art. The Coronation brought enormous numbers of foreign clients to swell the already long list at the House of Hartnell. The workrooms ran at full capacity and the company had to rent extra space outside its main building. Security surrounding the design of the Coronation dress and the dresses for members of the Royal Family was strict and always difficult to maintain.

BELOW LEFT Apart from these designs, Hartnell was also commanded to redesign the Peeresses' robes, unchanged since the reign of Queen Anne, to be made within a relatively low fixed budget with a new Cap of State. He also designed a head covering for ladies attending in short evening dress, drawing six of the former and thirty of the latter. The Queen assented to the final choices, some of which are shown here in the Hartnell salon, with the famous glass chimneypiece just visible, far left.

OPPOSITE Five of the Queen's six Maids of Honour, who carry the sovereign's train, were photographed by Cecil Beaton in the spring of 1953 in glamorous, sparkling white evening dresses.

OPPOSITE The sophistication of Hartnell's designs for the young Queen Elizabeth II is epitomized in the flowing lines of a new development for crinolined dresses intended for grand occasions of State. The touch of gentle humor in the holding of the Garter ribbon, bottom left, is typically Hartnell, revivified by the talent of his assistant Ian Thomas, a superb draughtsman, who would later be the third of the Queen's couturiers. The second, Hardy Amies, had begun designing for her in 1950. Designs for the Coronation included: the dress worn by Her Majesty the Queen Mother, top row center; the dress designed for Her Royal Highness Princess Margaret, top row right; the design for Her Royal Highness, Princess Marina, the Duchess of Kent, and widow of the fourth son of King George V, who was know for her style and elegance, bottom row center; and the Coronation dress of Her Majesty Queen Elizabeth II, bottom row right, as finished for Hartnell by Thomas. These designs were issued to the press on instructions from Buckingham Palace.

RIGHT Hartnell displays sketches of his designs for the Coronation dress and those of the other Royal Ladies at the reception for the press in his salon.

CORONATION COUTURE: *BEHIND THE SCENES*

OPPOSITE Proudly bearing the Royal Warrant, a Hartnell delivery van awaits a shrouded consignment on its way to an expectant client. The secrecy concerning the design of royal dresses involved painting out the windows of the workrooms with whitewash and taking other elaborate precautions to avoid prying eyes, press cameras, and wholesale manufacturers. This mews workroom reflected the acute shortage of space in the enormous Hartnell building during the lucrative years of 1953 and 1954.

RIGHT Recent conservation work in 2003 on the Coronation dress reveals the stupendous variety of designs and work which went into the creation of this Hartnell masterpiece. This was the final design of several and at the Queen's suggestion displays the emblems of the countries forming the United Kingdom and British Commonwealth such as the Scottish thistle, the Irish shamrock, and the British rose.

CORONATION COUTURE: *THE BIG DAY*

OPPOSITE The publicly crowned Queen Elizabeth II of the United Kingdom of Great Britain and her Dominions Across the Seas is part of the procession that slowly moved towards the nave and west doors of Westminster Abbey. Resplendent in her Hartnell Coronation dress, the Queen is flanked by the Archbishop of Canterbury, on her right, and the Dean of Westminster, and followed by the six Maids of Honour in their Hartnell dresses, who support the heavy embroidered velvet train. They in turn are followed by the Mistress of the Robes. The long walk up and down the aisle of the Abbey taxed the ingenuity of Madame Isabelle, Hartnell's premiere seamstress. At first, the heavy dress lurched like a ship at sea, but the skilled Parisienne evolved a lining and backing of cream taffeta reinforced with three heavy layers of horsehair crinoline giving, as Hartnell wrote, "a dignified and gentle movement."

RIGHT As intended by the designer, the gown held its own amid the colorful ceremonial uniforms, robes, and dresses of the participants and attendants. It did not detract from the Queen's personality; rather it projected her regal serenity as intended.

BELOW RIGHT The newly crowned Queen Elizabeth II rides in a golden carriage to the acclaim of the crowds lining the route to Buckingham Palace.

A TWENTY-SEVEN-YEAR-OLD GIRL IS CROWNED OUR 'UNDOUBTED QUEEN.'

ELIZABETH II, IN THE GOLDEN RADIANCE OF QUEENSHIP, HEARS THE HAPPY ACCLAMATION OF HER PEOPLE.

Picture Post, 13 June, 1953

LEFT Queen Elizabeth II emerges from Westminster Abbey into the daylight to a roar of public acclaim. The exit was through a specially designed pavilion to protect and accommodate the participants, proving necessary as it was a rainy day. The Queen entered the State Coach for the procession back to Buckingham Palace through the vast crowds.

OPPOSITE The young, newly crowned and radiantly serene Queen Elizabeth II is seen on the cover of *Picture Post* in a world-famous image. In addition to the weight of the Hartnell Coronation dress and robes, the crown weighed seven pounds, making the Coronation a physically testing day for Her Majesty.

OVERLEAF On Coronation Day, the immediate Royal Family was photographed in the Throne Room of Buckingham Palace. Those in Hartnell dresses include, front row fifth from the left: Princess Alexandra, her mother, the Duchess of Kent, Princess Margaret, Queen Elizabeth II, and the Queen Mother. (The Princess Royal and the Duchess of Gloucester stand to the left of the Queen Mother.) In the rear, from the left, are the Duke of Gloucester, Prince Philip, and the Duke of Kent. Front row, from the left, wearing kilts, are Prince Michael of Kent, Prince William of Gloucester, and Prince Richard of Gloucester. Madame Emilienne, who was in charge of making the Queen Mother's dress, found that the jewelled-feather embroideries and heavy border of gold tissue at the base of the crinoline caused it to hang, as Hartnell described, "in limp and disappointing nuance." So the gown was "glorified into regal fullness by mounting it on an underskirt of ivory taffeta laced with bands of horsehair and further strengthened with countless strands of whalebone." The magnificent floating effect was enhanced by gold high-heeled platform shoes.

PICTURE POST

Vol. 59, No. 11

13 June, 1953

I/-

*Special
Coronation Souvenir
Number*

God Save the Queen

THE ROYAL TOURS

Beginning with the 1938 State Visit to France and continuing until his death in 1979, Norman Hartnell designed painstakingly planned wardrobes for the overseas visits of the Royal Family. Hartnell made the majority of the dresses worn on these trips abroad, but Hardy Amies was also used by the Queen starting in 1950. Coordination and cooperation among the designers was essential. "When Her Majesty appears in a group with the other royals, no two must appear in the same colour, no two must clash, no two must wear the same sort of hat," noted journalist Anne Edwards. "And the Queen must always command the center stage." As Hartnell explained to the *New York Times* in a 1976 interview: "She should be totally conspicuous without being vulgar."

Over the years, Hartnell developed an intuitive understanding of how the Queen should look, which he described as "up-to-date but regal." This became second nature: he created dozens of unforgettable grand evening gowns for State Occasions. Abroad, they reflected the country in which they were worn, incorporating national flowers in the embroideries. This tradition was followed by both Amies and his assistant Ken Fleetwood, and later by Ian Thomas, Hartnell's former assistant. Such visits required at least two of these evening dresses, because the Queen always gives a formal dinner to thank her hosts for the State reception they have given in her honor. It would be considered discourteous to her hosts if the Queen wore the same garment twice during a trip or even on two different trips. "After all," Hartnell said in an interview in the *New York Times*, "if she wears one dress in Philadelphia, she can't wear the same one in Washington. They would take it personally."

Hartnell well understood that he had to consider all the accessories worn by the Queen in a specific country, something he first learned when preparing the 1938 State Visit of King George VI and Queen Elizabeth to France. "I took care that the Gala evening dresses had small sleeves or straps, either broad or narrow, on which to affix the Orders of the scarlet Legion of Honour [or] the blue sash of the Garter."

Sensible rules evolved for royal evening clothes. According to Edwards, "The dress must never have a long train lest some flustered diplomat should tread on it and be embarrassed. Hem lengths must always be toe-free to allow the Queen to walk without lifting her skirt or catching her heel or foot in the hem."

Hartnell said of the day clothes: "She can't wear skirts that are too tight for her to get out of a limousine or pleated ones that the wind might blow up at a garden party." He told the *New York Times*: "Her hat has to be off her face so that her picture can be taken and it can't be so big that she has to hold it to keep it from blowing away. After all, a Queen needs one hand for accepting bouquets and another for shaking hands."

As Hartnell approached his fiftieth birthday, the Queen also began to use Amies to design her day clothes. The team of Hartnell-Amies worked overtime to produce enough summer clothes for the extended Royal Tour of the British Commonwealth—from November 23, 1953, to May 15, 1954. For the first time, cotton dresses by the chic ready-to-wear British dress manufacturer Horrocks were included. This was to be the most extensive Royal Visit ever made, and Hartnell produced the hundreds of dresses worn during engagements in Canada, Bermuda, Jamaica, Panama, Fiji, Tonga, New Zealand, Australia, Cocos Islands, Ceylon, Aden, Uganda, Libya, Malta, and Gibraltar.

Working to establish guidelines, the two men's complementary talents ensured that the Queen was always the best-dressed woman anywhere in the world. Nevertheless, the Royal Ladies were never conventionally fashionable. "The Queen and the Queen Mother do not want to be fashion setters," Hartnell explained to the *New York Times*. "That's left to other people with less important work to do. Their clothes have to have a nonsensational elegance." Hartnell surpassed this repeatedly.

RIGHT The post-Coronation 1954 Royal Tour of the British Commonwealth lasted for six action-packed months, with every nuance captured in newsreels and the international press. The movie poster remains an engrossing study of monarchy at work in colorful settings.

X presents

ATURE

COPE

THE ROYAL TOUR
OF QUEEN ELIZABETH
AND PHILIP

FLIGHT OF THE WHITE HERON

Gordon Craig Released by 20th Century-Fox

LEFT AND OPPOSITE A selection of Hartnell's mid-1950s dress, coat, and skirt designs for Queen Elizabeth II reflect her change to a more youthful image. The use of stronger colors and patterns is contrasted with a design of the same time for Queen Elizabeth the Queen Mother, bottom row, far right. The sleek lines of the young Queen's style differed from her mother's established look, as seen here in the pastel draped and waist-tied dress, offset by a feathered hat and triple strand of pearls. The plaid coat, bottom row, second from right, typified the image of the Queen and was worn in Masterton, New Zealand, during the 1953–1954 Royal Tour. The dress, opposite, top row, far left, was worn in Tonga at an outdoor feast given by Queen Salote. Small off-the-face hats were fashionable and suitable for visibility. The two ensembles, top row, with pleated skirts could be worn by the Queen at Balmoral Castle in Scotland or a country engagement.

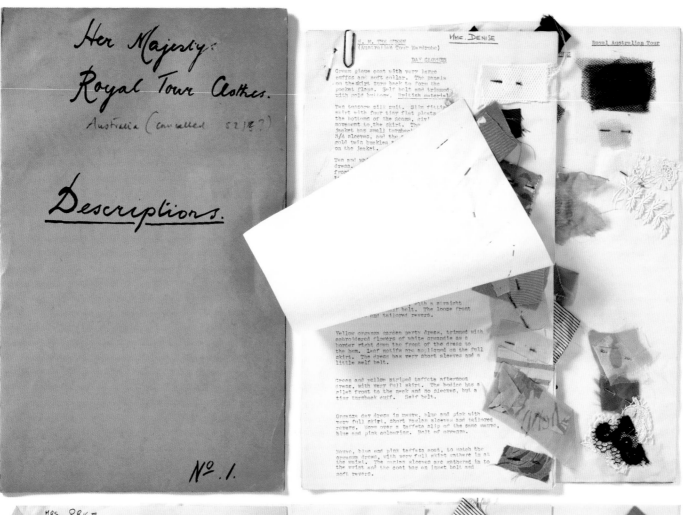

LEFT A partial selection of the essential sheets of descriptions and swatches from the Hartnell wardrobe designed for the Queen's Royal Tour of 1953–1954. Some sixty ensembles, mainly day wear, were described. These lists were used by Hartnell as well as by Ann Price, who was his redoubtable secretary from the war years until his death in 1979; his business manager, Captain George Mitchison; the workrooms; and the press office. Identifying and managing the numerous dresses was the work of the Queen's dresser and life-long servant Miss "Bobo" McDonald and her staff. The many accessories—hats, gloves, shoes, bags, stoles, and scarves—were also included, as well as the fabulous jewels chosen as appropriate for each occasion and outfit. The organization of such a tour is a massive undertaking.

OPPOSITE Newspaper clippings reported the rapturous response to Queen Elizabeth and Prince Philip as they firmly cemented ties with the Commonwealth, and pro-claimed the resurgence of British global influence following World War II. The international headlines provided an antidote to the gloom of the Cold War and the growing worries of the Russian nuclear capability. Especially in the exotic settings, the Queen's clothes fascinated both women and men. In New Zealand, Hartnell's elegant slate-blue day dress worn with a feathered hat by Claude St. Cyr emphasized the Queen's youthful regal elegance, and contrasted with the vibrant yellow-striped ready-to-wear cotton dress from Horrocks she wore for a less formal occasion.

FOLLOWING PAGES A French tribute to the designs of Hartnell and Hardy Amies highlighted the varied selection of the Queen's day clothes for the Royal Tour of 1953–1954, and showed the versatility required for different climates. Although each ensemble was different, there is an overall unity. Both designers admired the unique skills of the other, and it is often difficult to distinguish between their designs for the Queen at this time.

SUNSHINE CLOTHES FOR SUNNY LANDS

THE NATIONAL EMBLEM of New
the fern, inspired the choice of this pale
shantung with a grey fern print. Norma
designed the afternoon dress which the Quee
ing in the picture above. It can be seen in de
cover. The bodice has a square, shawl nec
skirt is flared with an apron front. The h
blue feathers, was designed by Claude

THE QUEEN CHOSE a cotton
from the Horrockses ready-to-wear summe
which was then made to measure for inclu
royal wardrobe. A simple, cool design
Victorian wallpaper print in acid yellow
rose, it was one of the first dresses to be
Queen (extreme left). The original off-the-
is available in many shops, priced at

Robe bleu marine avec impressions blanches, grand chapeau assorti. (Canberra, Australie.)

Robe en filet de nylon bleu roi, avec jupe plissée et chapeau blanc. (Melbourne, Australie.)

Simple et coquette robe de tissu rayé habilement taillée. (Melbourne, Australie.)

Robe beige pâle avec ample jupe et petit chapeau blanc. (Wellington, Nouvelle-Zélande.)

Robe et manteau Cognac à pois noirs, chapeau et gants noirs. (Wellington, Nouvelle-Zélande.)

De gauche à droite : Robe bleu pâle avec motifs de feuilles de fougère. (Ceylan.) — Robe en dentelle et petit chapeau. (Sydney, Australie.) — Ensemble en soie beige à pois blancs. (Sydney, Australie.) — Robe jaune pâle à rayures blanches. (Iles Cocos.)

Robe bleue et blanche, chapeau

Robe de cocktail à la jupe

Robe légèrement imprimée

Robe de coton à rayures

Robe d'été à la jupe ample et

PAR ELIZABETH II PENDANT SON VOYAGE

Robe blanche avec impressions vert émeraude, chapeau vert émeraude. (Ceylan.)

Ensemble d'été d'une rigoureuse simplicité, petit chapeau. (Brisbane, Australie.)

Robe blanche à pois noirs et tout petit chapeau. (Auckland, Nouvelle-Zélande.)

Robe, chapeau et gants gris acier, chaussures et sac blancs. (Canberra, Australie.)

Fourreau de dentelle blanche avec chapeau de tulle noir à large bord. (Sydney, Australie.)

De gauche à droite : Robe bleu pâle avec dessins blanc et noir. (Rockhampton, Australie.) — Robe de soie avec pan à effet de tablier. (Entebbe, Ouganda.) — Robe à jupe plissée et à corsage drapé. (Hamilton, Nouvelle-Zélande.) — Robe cyclamen avec impressions noires. (Darfield, Nouvelle-Zélande.)

Robe avec broderie anglaise

Robe de mousseline blanche aux

Ensemble blanc avec chapeau

Ensemble blanc avec dessins

Robe jaune avec effets de plissés,

H.M. THE Queen's
Australian Tour
1953-4.

OPPOSITE The variety of Hartnell's designs for the Queen's wardrobe during the Royal Tour of 1953–1954 was reflected in photographs of the numerous engagements the Royal Couple undertook throughout the Commonwealth. The buttercup-yellow dress, top left and center right, with its horizontal pleated skirt, was also designed without sleeves for warmer weather.

RIGHT With a visit to Nigeria in February 1956, the Queen resumed her tour of the Commonwealth countries. Hartnell created another African wardrobe, but for a hotter climate. A brightly patterned day dress for the Queen's reception by the King and Governor General was featured on the cover of the popular French magazine *Paris Match*, which regularly reported on the British Queen's activities and clothes.

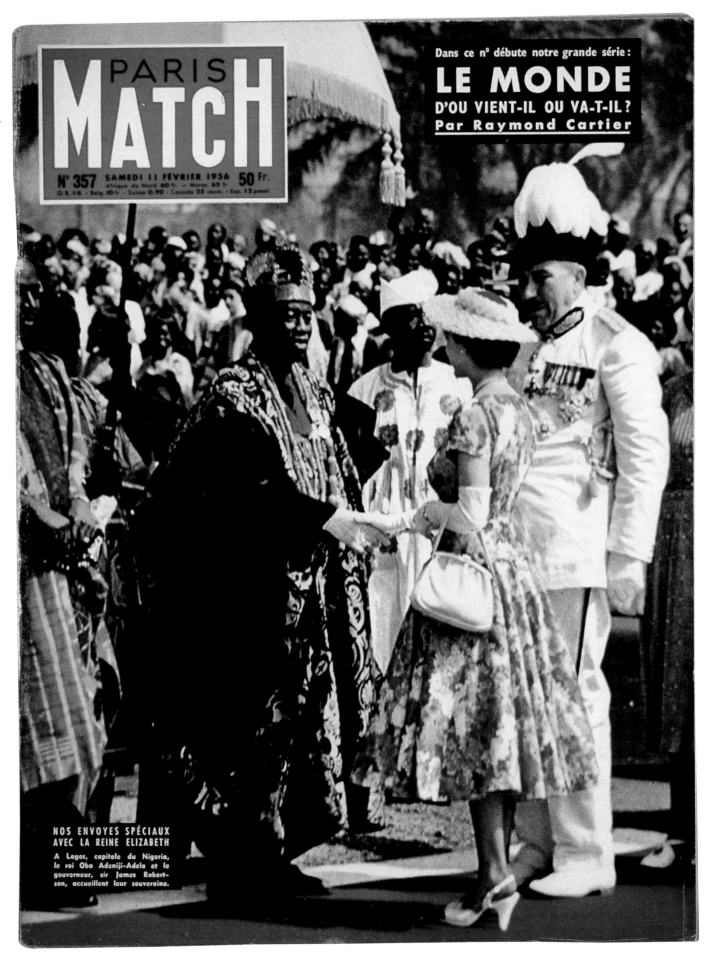

PARIS MATCH

N° 357 SAMEDI 11 FÉVRIER 1956 50 Fr.
Afrique du Nord 60 fr. — Maroc 65 fr
G.B. 1/6 · Belg. 10 fr. · Suisse 0.90 · Canada 25 cents · Esp. 12 peset.

Dans ce n° débute notre grande série:
LE MONDE
D'OU VIENT-IL OU VA-T-IL?
Par Raymond Cartier

NOS ENVOYES SPÉCIAUX
AVEC LA REINE ELIZABETH
A Lagos, capitale du Nigeria, le roi Oba Adeniji-Adela et le gouverneur, sir James Robertson, accueillent leur souveraine.

AND OH, SO GAY!

The Queen smiles in the sunlight of Gay Paree . . . and the city takes a holiday. Prince Philip ("I never expected anything like this") stands with the so-gay Queen on the balcony of the Elysée Palace (left), where the Royal couple are staying. Spring in Paris had never been so gay before —and that's saying a LOT! The bands played . . . the men shouted: "Vive la Reine" . . . and "She is so beautiful," cried their wives. The Queen and Prince Philip moved from the balcony . . . and for just a while she was "Our Queen" to the French. This is one Spring "Gay Paree" will NEVER forget.

Now isn't this a coincidence!

By JEAN MACAULAY

GREAT minds don't only THINK alike, they DESIGN alike.

Paris said on Wednesday that to look chic the Queen should wear:

A Claude St. Cyr turban HAT, her own PEARLS and EAR-RINGS, a TWO-PIECE finished with a draped scarf and a slim SKIRT cut for easy walking, a BAG she could hang over her arm.

Her Majesty arrived at Orly Airport WEARING: A Claude St. Cyr tammy-type HAT, her own PEARLS and EAR-RINGS, a TWO-PIECE with a mink scarf collar, a slim SKIRT cut for easy walking, a BAG she could hang over her arm.

The Queen as "France Soir," the Paris newspaper, wanted her to look was IDENTICAL almost with the Queen as NORMAN HARTNELL dressed her for the big day.

The smiles that captivated Paris... and here's one of the happiest-ever pictures of the Queen and

The glittering scene during last night's banquet for the Queen in the Elysée Palace.

'GRAPHIC' EXCLUSIVE—what the Royal visit did to the French

QUEEN GETS A PARDON FOR LOUIS THE KNIFE

JAMES MAYO — Paris, Saturday

BUT HARTNELL?—PARIS NEVER HEARD OF HIM!

Norman Hartnell at his Windsor home yesterday. Picture by STANLEY DEVON.

The vision that Paris remembered last night when the cost of the was revealed at a thousand million francs—A MILLION POUNDS it," said Paris financial journals, "every sou, for our four-day

THE DRESS of the YEAR
—And 100,000 around the Opera gasp to see a glittering Queen

From SYDNEY SMITH — Paris, midnight

PARIS, the home of superlative clothes, used up all its superlatives tonight on the Queen —and especially on That Dress.

The world's best-dressed women, gathered at an Elysée Palace banquet and at the Opera, were overwhelmed.

The Dress was of ivory satin embroidered with pearls, topaz, and gold to represent the flowers of the fields of France.

It was created by Norman Hartnell of London.

But look what Mr. Hartnell had to say about it all in Paris tonight:

"Frankly," he said, "the Queen is not much interested in fashion."

Robb goes in close where cameras cannot go

WORLD COPYRIGHT RESERVED

MAGNIFIQUE!
'Never has she looked stunning, so chic, so

The quick-change Queen dazzles Paris crowd

From PETER STEPHENS in Paris

THE Queen changed outfits four times in seven hours yesterday, providing Paris with a spectacular display of royal fashion.

PARIS 11.56 am — The Queen, wearing her second outfit—including a sombrero-type hat favoured by Princess Anne—is met in Paris by President Pompidou.

LONDON 11.09 am — The Queen leaves Heathrow in the first of four costumes she wore during the day—a Hartnell outfit of pale lemon.

Princess Anne in a hat copied by the Queen

THE DAZZLER — The Queen, looking relaxed and regal in her fourth and most glamorous outfit, arrives for the State banquet at Versailles with Prince Philip and President Pompidou.

Norman Hartnell.

PREVIOUS PAGES LEFT During the State Visit to Paris in April 1957, the Queen wore a supremely elegant heavy satin-silk coat dress by Hartnell. The Magpie design was a variant of his black-and-white styles, most notably a sensationally simple black-and-white satin halter-necked evening dress worn by Her Majesty in 1952 for a royal film show.

PREVIOUS PAGES RIGHT Hartnell and Amies provided the wardrobe for the Queen's 1957 State Visit to France and met there. Amies conceded that Hartnell's evening dresses were the triumphs of the trip. The dress worn for the gala at the opera, bottom left, is as great an achievement as the one Hartnell designed for her mother the Queen Consort, Queen Elizabeth, for the same occasion during the State Visit of 1938. The bouffant trailing line held by a large bow and the sublime embroidery on the satin utilizing the Napoleonic bee as a motif are examples of Hartnell's powers of invention for unsurpassed grandeur married to elegant line. The crinoline design had evolved further and gave Hartnell the chance to more than rival Charles Frederick Worth, the nineteenth-century British inventor of modern French couture. In May 1972, the Queen again dazzled Paris, and the headline at home described her as "Magnifique," bottom right.

LEFT The motif of the maple leaf, shown in a sketch, formed the embroideries for an outstanding green satin evening dress worn at the banquet in Government House, Ottawa, in 1957. The background leaves are of velvet outlined with black and glass bugle beads, and the flower heads of silver and emerald are set among an organized drift of smaller silver beads. Homage was paid to the Canadian national emblem to suitable acclaim.

ABOVE AND ABOVE RIGHT Two other dresses from the Canadian Royal Visits of 1957 and 1959 emphasize the development of the Hartnell line from the crinoline to the reinvention of the bustle, above right. The very slim Queen was dressed in velvet, the grandeur highlighted by a floating silk chiffon–gathered train held by a bow. The sophistication of the sketches is due to Ian Thomas, Hartnell's assistant, who often spent weekends at Lovel Dene, the designer's country house, exchanging ideas, polishing his sketches, and increasingly lending his own vision to the creative process.

LEFT Hartnell redefined his designs for the Queen's day clothes for the State Visit to the United States in October of 1957. The result echoed his successes of the early 1930s in creating elegant slim-line silhouettes. The fur-collared velvet coat, top left, was especially praised and later worn at home for several royal engagements.

OPPOSITE The demand for grand evening dresses for State Visits continued and was emulated by Mrs. Eisenhower, who was photographed with President Eisenhower and the Queen. Both the Queen's and Mrs. Eisenhower's dress are typical of the late 1950s style with flowered full skirts. The great difference lies in the embroideries applied to the skirt of the Queen's dress, which set it apart from any other likely to be encountered.

In his **London salon** Norman Hartnell inspects models wearing clothes he will show this month in Vancouver, Calgary, Winnipeg, Toronto and Montreal when he makes a cross-country tour. The taffeta and moire evening gown is pink; the barrel-shaped coat and sheath are black wool.

Jack Esten

LEFT It was not unusual for Hartnell to be on hand during a State Visit or Royal Tour, in case his dresses needed his personal attention. In this instance, he designed clothes for sale commercially in Canada, taking advantage of the publicity engendered by a Royal Visit. This photograph was taken in his mirrored Mayfair salon.

"Royal" Clothes Come To Canada

Norman Hartnell, the Queen's dressmaker, is now designing for the women of this country

By Marjorie Earl

Jack Esten

He started career by designing stage costumes and this still interests him. Studio adjoins his cottage in Windsor Forest.

LONDON, ENG.

A HAND-PRINTED white card stuck incongruously to an imposing door in the muted upper regions of London's most elegant commercial establishment carries the following stern but false warning:

"No admittance beyond this door except by express permission of Mrs. Price."

Above the card, chaste lettering on a metal plaque proclaims that the sequestered personage behind the door is Norman Hartnell, the Queen's dressmaker.

Hartnell, as all the world knows, is important enough to deploy an army of Mrs. Prices to keep distractions at bay. But since he is that rare bird, an important man without airs of importance, Mrs. Price, who is his secretary, is often not present to do her guarding, the door stands ajar, anybody can walk in and everybody does.

A thick-set man with reddish-brown hair, blue eyes and a rugged face that is usually softened by a whimsical, detached smile, Hartnell is so accessible that he recently consented to an unscheduled interview on the worst day of the year — the day before he showed his fall collection to foreign buyers visiting London. Without so much as consulting Mrs. Price, the go-between responsible for this inconvenient meeting simply put his head **(Continued on Next Page)**

RIGHT For the Queen's July/August 1959 Royal Visit to Canada, Hartnell began preparations well in advance for the wardrobe he was commanded to create. As four of his designs illustrate, he concentrated less on the shortened Princess Line for the day clothes and more on the emerging slim line favored by the Queen. The success of such clothes helped to revivify his business at a time of change in the British fashion world. They recalled the elegant simplicity of line for which he had been famous in the 1930s and 1940s and retained minimal decorative effects in muted colors and a shorter hemline.

UDICATA CON SINCERITÀ DAL SARTO SCHUBERTH

famoso vestito del ricevimento al Quirinale - Una cappa da abolire senza rimpianti - Tasche inutili e cappello da scolaretta

OSI È APPARSA LA SOVRANA INGLESE FRA N

LEFT The State Visit to Italy in May 1961 was preceded by a short private visit. Hartnell was commanded to create a wardrobe to be worn in a warmer, but not hot, climate and to include some grand evening dresses. A slimmer silhouette predominated in a succession of acclaimed elegant day ensembles worn with higher small hats. For evening, a bouffant variation of the fuller crinoline, bottom left, appeared with minimal striated vertical bursts of linear embroidery and a geometric checkered bodice—the beginning of a new phase in design in the wake of the Sputnik motifs.

OPPOSITE For the separate State Visit to the Vatican City on May 5, 1961, the Queen wore a slim black silk gown with an underskirt surmounted by a soft bell-like overskirt of stiffened lace. The yoke neckline was filled in with gauze appliquéd with lace flowers, and attached to the tulle veil worn mantilla-like under a tiara for an audience with Pope John XXIII. The Queen, accompanied by Prince Philip, wears a pearl necklace from her grandmother and Queen Alexandra's tiara. This was an event of great political and religious significance. As the Queen is the Supreme Governor of the Church of England, the meeting marked the first official meeting of the heads of the two churches since the sixteenth century.

L'ELEGANZA DELLA REGINA ELISABETTA IN ITALIA

La fortuna di Sua Maestà: una figura snella - Un elenco di errori che ha fatto epoca - Gli effetti miracolosi di un colpo di pettine

UNA "TOILETTE" DIVERSA PER OGNI OCCASIONE.

OPPOSITE At the end of their visit to New York in October 1957, the Queen and Prince Philip receive the acclaim of the guests at the Commonwealth Ball at the 77th Regiment Armory held in their honor. Shortly after this photograph was taken, the Royal Couple left for their airplane. Hartnell described to the press how the tulle fantail of the Queen's iridescent embroidered slim dress floated out and glittered under the klieg lights as she crossed the tarmac and walked up the steps to wave goodbye to America.

RIGHT Hartnell designed a series of dresses for the Queen's State Visit to Denmark in May 1958. The new slim-line figure recalls the heavily beaded slinky dresses for which he was famous in the 1930s. The gold dress embellished with embroidered and hanging beadwork with a diadem and Robes of State in 1956 is a descendant of his prewar successes, with a clear 1950s touch. It was designed as a suggestion for the State Opening of Parliament and also worn by the Queen for the banquet given by the King of Denmark at the end of his State Visit to Britain in 1959.

a Suggestion for The State Opening of Parliament.

EXPRESS WEDNESDAY FEBRUARY 1 1961

SEEN FOR THE FIRST TIM ... THER *Robb* SPECIAL

Hartnell's India wardrobe for the Queen

TO THE LAND of mystique and minarets the Queen has taken the kind of clothes that can even steal the picture from the Taj Mahal, rival the magnificence of the maharanis, stand out against the massed millions who line the routes to greet her. For this royal visit, Norman Hartnell (left) creates clothes of great splendour and extravagance—colours to compete with the rainbow dyes of the sari, opulent embroidery, and a line she already loves, knows, and is happy in.

Queen's state gown of crescent lace richly embroidered in the Hartnell manner with crystals, pearls, and diamonds.

White ribbed silk

Slender column of white crepe, embroidered in graduated scallops of diamonds and emeralds to echo the jewels in her tiara.

Coin sized dots of

A dress and coat in one of the Queen's favourite colours—ice blue. The toque hat is a swirl of tulle and matching flowers.

Beige satin faille for an afternoon dress and matching full length coat. The dress is gold embroidered, the coat mink-trimmed.

Daily Telegraph and Morning Post, Thursday, February 23, 1961 13

DRESSING AS A 'QUEENLY' QUEEN

EASTERN AND WESTERN IDEAS DIFFER WIDELY

THE Queen's visit has become the fashion event of a lifetime for Indian and Pakistani women.

Fascinated by her youthful good looks—" Such a lovely waistline. Who could believe she is the mother of three children? "—they have devoured every detail of her appearance and her dress.

Our correspondent on the Royal Tour reports that the women like it best when she looks " queenly "—that is in grand, sweeping dresses, glowing colours and sparkling jewels.

Pakistani women were enraptured by the full-skirted Hartnell evening dress worn for a State banquet in Lahore. It is sketched left. In gleaming turquoise satin, embroidered with white beads, seed pearls and diamonds, it is exactly the sort of grand dress they love, because it is so different from their own way of dressing.

It was much preferred, for instance, to one of the loveliest slim evening gowns of the tour. It was of white crêpe embroidered from head to foot in scallops of crystals, diamonds and pendant emeralds (far left).

The understated elegance of the Queen's slim dresses that pleases Western eyes leaves the Eastern women cold. The absolutely plain white crêpe day dress in the sketch was most becoming in its severity. But Pakistani women found it too simple. " It's not queenly at all," one pretty young career woman said.

Many of the royal clothes seem to have been chosen as an implied compliment to local and national pride.

The Indians were thrilled when the Queen wore marigold and whit... the marigold garla... deep salmon colou... city," will never b... those who saw her.

● *The Queen has shown an inspired sureness in choosing just the right dress or accessory for the occasion on this tour. What could have been a more delightful gesture to the tribal chiefs of the Khyber Pass than to choose a hat that was a subtle copy of the straw kulla, the hillmen's dome-shaped basic hat which is then swathed with a cloth turban.*

SKETCH BY BERYL HARTLAND

Norman Hartnell
OURRANT'S PRESS C...

The EAST likes grand dresses and lots of jewels: the WEST likes slim and simple elegance

LEFT AND OPPOSITE In the spring of 1961, the Queen made a State Visit to India and Nepal. She and Prince Philip were greeted at the Delhi airport by President Rajendra Prasad, second from the right, and Vice President Sarvepalli Radhakrishnan, together with other government officials and Indira Gandhi, far left. Her elegant white silk ensemble displays the fashionable straight silhouette. Her loose coats were perfectly adapted for the heat. The style was continually updated thereafter by the Queen's designers. By the 1970s, Hartnell, Hardy Amies, and Ian Thomas no longer used a matching loose-fitting coat as a regular component of the look.

THE YOUNGER SISTER

From her birth in 1930 until her marriage in 1960, Princess Margaret was a leading trendsetter, the darling of the press—as Diana, Princess of Wales was to become during the 1980s. Princess Margaret then had the freedom to express herself more than her sister. She did not have the burden of being heir apparent, although she was second in line to the throne until 1948 when Prince Charles was born. Princess Margaret was usually dressed like her elder sister, Princess Elizabeth, until the end of World War II. By the early 1950s, she had become a fashion icon and was one of the first to wear the postwar New Look. Young women all over Britain followed her lead, and as one 1953 magazine article noted, "What she wears is News. It is seen by thousands of women in person, hundreds of thousands on newsreels, millions who read the newspapers and magazines." Another publication declared: "The Margaret Look came to mean simple elegance for the younger set."

Norman Hartnell was largely responsible for the Princess's image. (She later wore clothes by Christian Dior and Victor Stiebel.) He made his first dress for her when she was five years old and a bridesmaid at the marriage of her uncle, the Duke of Gloucester to Lady Alice Montagu-Douglas-Scott, but did not design for her again for some time. During her childhood and early adolescence, she wore girlish or sensible clothes, and it was not until 1947, on her first Royal Tour, that she was provided with a glamorous couture wardrobe. For this trip to South Africa and Northern Rhodesia (now Zambia), some of the day dresses were by Edward Molyneux, but all the evening dresses were by Hartnell.

Having had a relatively solitary wartime childhood, Princess Margaret blossomed into a beautiful young woman, known for her wit and interest in the arts. It was during the 1947 tour that she first met Group Captain Peter Townsend, attached to the Royal Household for the visit. Later, having to weigh her love for a divorced man

against her duty to her country, duty came first. She became a sophisticated woman with extraordinary charisma, which fascinated the press worldwide.

Her clothes were always impeccable and never more so than on her wedding day. The dress Hartnell designed for her May 1960 wedding to the photographer Antony Armstrong-Jones was a tour de force. Made of silk organza with a skirt that required thirty meters of fabric, it had minimal embellishment to ensure that the bride and not the dress was the star of the first televised royal wedding. Princess Margaret credited Hartnell for being "always so good at getting the balance right."

Although she was a fashion plate, she was a Royal Princess first and foremost. "I have to have things which photograph well; there's no use in having a really pretty dress which does not photograph," she said. "I always, always have to be practical. I can't have skirts too tight because of getting in and out of cars and going up steps. Sleeves can't be too either; they must be alright for waving."

Her style was influential and legendary, but she was modest concerning her influence and interest in clothes. "I was never a trend-setter," she once said. "That was only what the fashion correspondents said. I followed fashion. You had to. Otherwise, what would have I looked like?"

RIGHT At a show of the Incorporated Society of London Fashion Designers in 1958, Hartnell is seated between two of his most important clients, Queen Elizabeth the Queen Mother and Princess Margaret, both wearing his designs. The Queen Mother is in a loosely fitting chic satin dress and coat worn with a small feathered toque. Princess Margaret's silk taffeta princess style day dress has paneled smocking typical of Hartnell's original designs for her.

A princess goes to a ball in Scotland's capital . . . dressed in the traditional white, the only touch of colour is the sparkle from jewelled embroidery. (Right) Being bridesmaid to a friend is an exciting event for any young girl, but in this role Princess Margaret's dress is youthful simplicity itself—with no trimmings whatsoever.

PRINCESS MARGARET

LEADER OF YOUNG FASHION

By

BETTY WARD-JACKSON

EVER since her childhood Princess Margaret has found herself a leader of young fashion. It started with those little ribbon-trimmed straw hats and impeccably tailored coats . . . and has mounted in interest and importance with the years until now her hats, her hairstyles and her hemlines have become world news.

Quite unconsciously this young Princess, for whom the bonfires will be lighted at Balmoral Castle on August 21, casts the final vote in thousands of family debates all over Britain and the Commonwealth.

Whenever the young daughter of the house goes campaigning for her first black evening dress, an amusing new hat, or some boogie-woogie gramophone records, she flashes out those familiar words: "Well, Princess Margaret has one!" or "Even Princess Margaret is allowed to do it."

A Fortunate Asset

TO be world fashion news might be a heady experience for some girls of twenty-one and tempt them to run to elaborate lengths in their dressing, but the Princess, fond though she is of good clothes and amusing accessories, is not bewitched by her mirror. She is quite unselfconscious—essentially of this age with her courage, wit and forthright charm.

Her dress sense is a fortunate asset which has grown as a result of her intelligent interest in smart clothes.

In her early teens she was quick to notice that her aunt, the Duchess of Kent, was the best dressed woman in the family circle, and she secretly determined to achieve the chic for which her aunt was already well known.

Her appearance was already much in her favour. Her daintiness, her slender waistline, her small feet and her lovely natural colouring were all there to inspire the dressmakers and to enhance their clothes.

As a little girl the Princess was known as 'Margaret Rose' and though the second name is no longer used, she regards the flower as her personal emblem. Scattered freely over the skirt, these satin roses give a romantic air to a formal satin gown.

14

LEFT AND OPPOSITE In the years following the war, the young Princess Margaret was the subject of intense international interest and increasingly became a fashion role model for her generation. Her appearance as a bridesmaid was not confined to the wedding of Princess Elizabeth in 1947. Each of her appearances occasioned coverage in the press and the newsreel. Although the use of Rose in her name was dropped at her request, the rose was Hartnell's motif for her dress, below far left.

THE YOUNGER SISTER: *BELLE OF THE BALL*

The maturing beauty of Princess Margaret was no challenge to Hartnell's designing skills. Known for her wit and interest in the performing arts, she was the perfect client for his most romantic innovations.

OPPOSITE Famous society portait photographer Dorothy Wilding was equally well known for her portraits of the Royal Family. This photograph of Princess Margaret shows her wearing the bridesmaid dress designed by Hartnell for the wedding of her sister, Princess Elizabeth, in 1947.

RIGHT Photographed in 1949 by Cecil Beaton, she wears a full-skirted, butterfly embroidered tulle and net evening dress with the same fichu neckline he had designed for her mother, the Queen, in 1939.

ABOVE AND OPPOSITE Princess Margaret encapsulated the dreams and desire for elegance and glamour of many young women at home and abroad. Her clothes, accessories, and hairstyles were copied around the world and she was the subject of numerous magazine covers. For Hartnell, who was approaching his sixties, the Princess was not simply another great royal patron, but a favorite client able to portray his skills to a new generation.

Two elegant day ensembles for Princess Margaret exemplify the look of the mid-1950s, as interpreted by Hartnell.

LEFT The verve of the striped design outlined with a deep white collar, which was to be worn with a matching wrap, reflected current fashion trends, aptly obsessed with the graceful look of the shortened Princess Line with its full skirt and narrow waist.

RIGHT A mid-1950s day dress for Princess Margaret has a sophisticated flattened bow at the front. Such details were less easily replicated by the increasingly capable ready-to-wear dress companies and mark Hartnell's easy triumph of couture skills over the expensive replicas his lesser competitors tried to make.

LEFT Fashionable Hartnell designs for evening dresses from the late 1950s for Princess Margaret reflect the period use of printed floral fabrics, bottom row, and the graceful attention to detail, top row.

In July 1953, the Queen Mother was accompanied by Princess Margaret on a Royal Tour of Southern Rhodesia (now Zimbabwe). Both wardrobes were by Hartnell.

RIGHT The Princess wears a full, slightly pleated belted dress with a double row of buttons on the bodice as she returns to London. A small hat, long white gloves, and white bag complete the outfit. The Princess wore variations of the high-heeled white sandals throughout her life.

The wedding of Princess Margaret to Mr. Antony Armstrong-Jones on May 6, 1960, was an opportunity for Hartnell to create one of his most beautiful and sophisticated wedding dresses. It remains his most refined design, the simplicity of line admirably suiting Princess Margaret and her petite figure. The subtlety of the veil created, to Hartnell's design, by Claude St. Cyr, the celebrated Parisian milliner (who had a concession in Hartnell's salon), added to the incomparable romance of the occasion. The marriage of the Queen's sister to a commoner marked the changing nature of British society. The design of the dress underwent several major changes from the straight line first proposed by the bride and groom. The final design echoed the Queen's Coronation dress of 1953 and was the culmination of the fashionable Princess Line of the 1950s. The many yards of white tulle forming the layers of the dress proved difficult to handle, as they either clung together or hissed in opposite directions. Only by the technical achievement of the Hartnell workrooms was this overcome after many trials. Hartnell also designed the dress to divide at the back, so that the Princess would emerge uncreased when her carriage arrived at the doors of Westminster Abbey.

LEFT The first public glimpse of Princess Margaret wearing her Hartnell wedding dress was through the windows of the carriage taking her to the church. The veil is secured to her head by the Poltimore tiara, and she also wore a diamond necklace given to her by her grandmother, the late Queen Mary. She is accompanied by her brother-in-law, Prince Philip, who gave her away.

OPPOSITE After the wedding, the newly married Princess Margaret and her husband, ennobled as Earl of Snowdon, were photographed by Cecil Beaton inside Buckingham Palace. Hartnell's glorious design remains his last true masterpiece for a State Occasion.

FAMILY PORTRAIT

RIGHT Her Royal Highness Princess Margaret and Mr. Antony Armstrong-Jones, created Earl of Snowdon, are surrounded by their families at Buckingham Palace following their wedding in Westminster Abbey on May 6, 1960. It was one of the last occasions in four decades when the Royal Ladies wore full-length dresses for a daytime engagement. For the Queen, Hartnell designed a full-skirted sea-green silk and lace dress with a bolero and a matching rose-embellished hat, a reference to Rose, her sister's second name. This design was intended to complement the wedding dress, and was notable for its lack of embroidery. The Queen Mother's dress returned to her straight silhouette of the past, and is balanced by a fur-trimmed stole. The elegance of Princess Marina, Duchess of Kent, to the right of the Queen Mother, is highlighted by Hartnell's long-sleeved silk dress, with its skirt of contrasting horizontal bands, while her daughter, Princess Alexandra, far right, wears a Hartnell tulip-shaped satin dress with a dividing front over a central panel. The Duchess of Gloucester, far left, whose 1935 wedding dress had resulted in Hartnell's many royal commissions, wears a typically elegant satin sheath with three-quarter sleeves and a simple collared neckline. The beautiful Countess of Rosse, standing between the Duchess and the young Prince Charles, was an early client of Hartnell's in the 1920s. As the mother of the bridegroom, she wore a fashionable short day ensemble with a magnificent hat in keeping with the occasion.

212

DAZZLING DESIGNS

Although Norman Hartnell's creations were worn by the world's most famous and most photographed women, not least the Queen and Queen Elizabeth the Queen Mother, Hartnell needed more publicity to ensure a steady stream of well-heeled women to his Bruton Street salon. He tirelessly considered new ideas and made specific trips abroad to further the Hartnell name.

In late 1953, he visited the United States to show his evening gowns on the Greek Line flagship *Olympia*, docked at the West 57th Street pier in New York City. The *New York Times* fashion reporter was bowled over by his work. "The elegance of these creations was reminiscent of a past era," she wrote. "The use of materials was extravagant, the embroideries were executed with the delicate touch of a jeweler's hand."

The newspaper praised Hartnell for importing three English models and one Spanish mannequin to wear the gowns. "Exhibiting them, and contributing much to their presentation, were four long-stemmed beauties who came to this country to display them. Perfectly trained in their movements, they crossed the dance floor of the ship's salon as if they were about to be presented at court." In his salon, he had learned how important the house models and the vendeuses were in creating an aura that would put women in the mood to spend a lot of money.

As one of the founders of the Incorporated Society of London Fashion Designers, he participated in group shows overseas, including one cleverly called "From Tweeds to Tiaras," presented in New York's Astor Ballroom in April 1960. (It was the same show presented a month before to the Queen Mother and Princess Margaret at Osterley

Park in London.) Once again, the *New York Times* was dazzled: "While the British tweeds lived up to their reputation, the ball gowns surpassed them. In tulle, lace, white satin, embroidered in varying kinds of crystals and pearls, caped in feathers, hemmed in mink, many had nine petticoats and most had skirts the width of an ordinary elevator. They were made for a nation of women who polka, minuet, and waltz."

Hartnell was one of the first British fashion designers to attain global celebrity. In the Commonwealth and beyond, his Royal Warrants as Dressmaker by Appointment to Queen Elizabeth II and the Queen Mother gave him fame and status. He knew how to give sound bites to the press. On a trip to New York in 1951, he told *Time* magazine that British women looked best in "tweeds," French women "in little black cocktail frocks," and American women "looked good in anything."

Hartnell did not really believe that. He dreamed of a world where everyone was exquisitely dressed. As he wrote in his 1956 autobiography, *Silver and Gold*: "What is the merit of choosing the drab when beauty hangs in the wardrobe?"

RIGHT Andrew Robb, a leading British fashion illustrator of the period, captures creativity in one of the workrooms at the couture house. Madame Emilienne, head of the workroom, compares Hartnell's sketch of Lemon Soufflé, created for the Queen, to the finished dress. A seamstress adjusts an ice-blue dress, right, one of the designs Hartnell made for the Royal Tour of 1954.

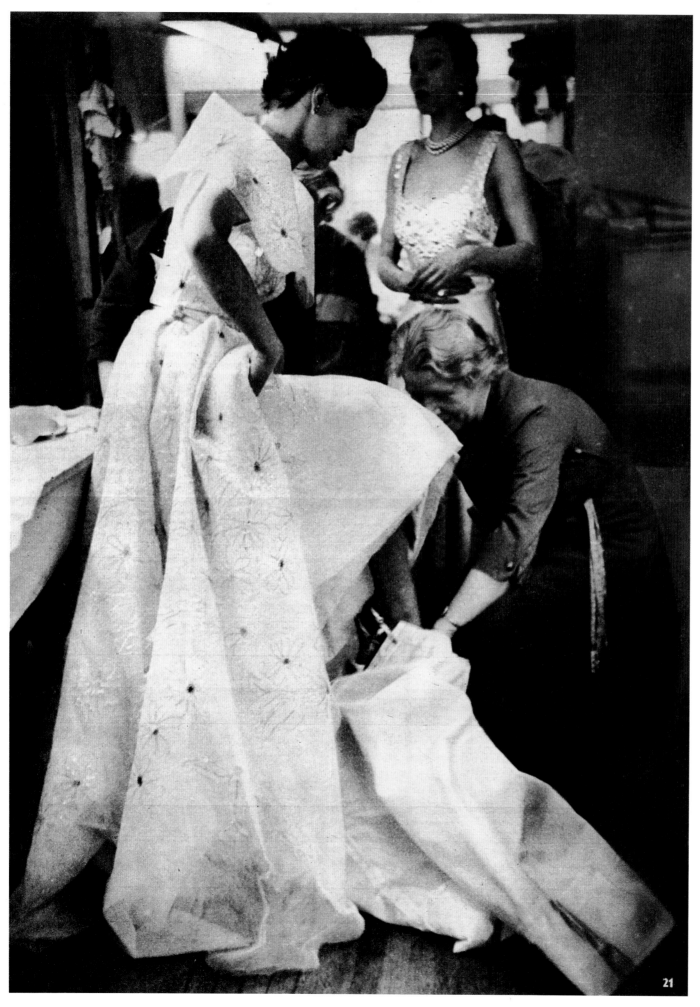

The success of the Hartnell salon relied heavily upon both the vendeuses and the models. If the contact between the sales-woman and client was made on a personal level, that of the model and client remained somewhat impersonal but nonetheless critical in displaying every nuance of a design. Hartnell listened to their opinions, as much as to those expressed in the workrooms. House models normally gave two to three shows a day of the current collection.

LEFT None of the house's models was more famous than the raven-haired Dolores, much imitated for her gliding walk and dramatic poses with arms out-stretched. She remained with Hartnell for three decades and gave a sense of drama to the clothes she modeled.

RIGHT Barbara Wimbush, a mother of two and a Hartnell mannequin, or model, is poised to take a nearly finished lavishly embroidered evening dress out of the workroom and onto the salon floor. The fitting of each dress to the individual model continued on to the last minutes before a show. Hartnell models were often famous. One of them, Jane McNeil, became the Duchess of Buccleuch. Others were chosen from Commonwealth countries for their looks and media appeal.

LEFT AND OPPOSITE At the peak of his career in 1953, Hartnell participated in a photography shoot by Norman Parkinson with favorite dresses from his summer Silver and Gold Collection—including the embroidered pale blue and white heavy-ribbed silk evening dress and coat with a lavish caped collar dropping to a point. Not one London house and few in Paris could equal the artistry of his in-house embroideries displayed in perfect contrasting harmony.

OPPOSITE A series of sketches from the 1950s illustrate characteristic Hartnell designs for Queen Elizabeth II. The swatches are of fabrics selected by the Queen. The same method of design applied to all Hartnell's private clients, who did not necessarily choose from the current season's collection. The growing emphasis on closely fitted straight lines for coats, skirts, and dresses became notice-able throughout the decade as the fuller skirts based on the shortened Princess Line fell out of fashion.

RIGHT The contrasting styles of Queen Elizabeth II and the Queen Mother as they were on view at Royal Ascot in 1960. The Queen wears a slim floral dress featuring an intricately tied bow at the waist and a gathered skirt at the back. The Queen Mother wears the late 1950s and early 1960s version of her Hartnell style: a loose coat over a gently swathed and belted polka-dotted organza dress worn with a small flowered toque.

In the late 1950s, air travel was both glamorous and expensive. The British Overseas Airways Corporation (BOAC), a forerunner of British Air, publicized its new facilities at the expanding Heathrow Airport by inviting Hartnell to a photography shoot.

LEFT Model Barbara Wimbush, in stiletto heels and a skin-tight suit, posed in a nipped pencil skirt and jacket with a leopard-print clutch bag and an aerodynamic hat, suggesting exotic travel.

OPPOSITE For the cocktail hour, long gloves offset the constellation-embroidered silk dress with its matching satin-lined wrap and pale high-heel shoes. In common with most designs of the period, smoothing corsetry was a necessity for women over a certain age hoping to attain a slim silhouette.

OVERLEAF Evening dresses for grand occasions were Hartnell's forte. He abhorred Coco Chanel's "little nothings," believing that "simplicity is the negation of the soul" when carried out in identical black dresses. Hartnell's ideal was Charles Frederick Worth, which placed him poles apart from Chanel.

LEFT A 1952 Princess Line coat with a wide-edged collar and three-quarter sleeves typifies the Queen's everyday dress when meeting her subjects early in her reign. It was distinguished from the dress of more affluent women only in the fine construction and detailing of the sleeves. She is seen visiting new public housing in Hertfordshire.

OPPOSITE Hartnell loved designing dresses in what he termed his Magpie style. Stark contrasts of color and fabric heightened the slimness of the wearer. This summer 1956 Ascot ensemble of heavy silk with lightly padded shoulders shows great verve in the contrasting belt. The gloves and cock-feathered hat offset the three-quarter sleeves. The Queen wore a version of this dress during her State Visit to France in 1957. Dresses were sometimes selected from Hartnell's current collection by the Queen. They were then withdrawn from sale.

LEFT Ian Thomas, Hartnell's assistant and sketch artist, drew this late-1950s day dress with his usual verve. As with many royal designs, the sketch was overly optimistic in its depiction of an exaggerated posture. The Queen wore the blue satin dress during her trip to America in October of 1957.

OPPOSITE This pale blue full-skirted satin cocktail dress was specially designed for a client in 1963. The narrow waist heightened by the large flat buttons of the time has a wide silk waistband ending in a long fringed sash. The contrasting gathered bodice draped to one side is characteristic of Hartnell's designs from the 1940s to the 1960s and was reflected in many of the dresses he designed for the Queen and the Queen Mother.

In the 1950s, British winters were usually snowy and cold. Central heating was not universal, and travel, before the development of motorways in the 1960s, involved drafty train stations and fog-bound journeys by road. Spring and autumn also had their chilly spells. Travel to and from Paris was by the swish Golden Arrow Boat train more often than by air.

OPPOSITE Hartnell in 1959, with a bevy of models, arrives at Ascot for a fashion show held in the Royal Enclosure.

RIGHT During the 1950s, the popularity of the tent coat, top right, in white wool, reached epic proportions with its dramatic swirls of expensive fine Scottish wool clutched with large decorative buttons, top left. For town, bottom left, silks and velvets were highlighted with hats by Hartnell's in-house Parisian milliner, Claude St. Cyr. The elegance of the flowing lines of the coat, bottom right, showed Hartnell's talent in designing serviceable day clothes with complex tailoring. The large leather traveling handbag, perfect for long journeys, struck a high note. Each coat afforded elegant warmth and protection from the elements.

loves VELVET

White and ivy green duchesse satin are used by Norman Hartnell for his ball dress which he calls "Rose Garden". Large satin roses and garlands of ivy festoon the crinoline

OPPOSITE Six glamorous Hartnell evening dresses worn by sophisticated women capture the romantic mood of the early to mid-1950s, when women aspired to maturity rather than prolonged adolescence. The young mother, top row far left, echoed an age devoted to family. The idea of the ivy-sprigged rose-adorned dress, bottom row far left, had its counterpart in the rose-embellished dresses created for Princess Margaret and in the maple-leaf dress the Queen wore in Ottawa in 1957. A heavy satin embroidered and beaded dress, bottom row center, worn at a 1952 show in Australia, displays the necessity of using the correct type of underskirts to avoid the dress falling flat.

RIGHT This white ribbed-silk dress from 1959 incorporated loose vermicelli beading and spangled embroidery on bodice and shoulder straps to echo the diamond necklace and earrings worn by the client. The asymmetric tucking at the waist creating a central flat panel in the bell-shaped dress was a development of the design used on an evening dress worn by the Queen in March of 1958. All Hartnell designs had names—this one is Crystal Clear—and the original design is marked as "Mr. Hartnell's favourite."

When elegant lifestyles involved sophisticated dressing—London evening life glittered with gala occasions, concerts, operas, theaters, cabarets, clubs, and plush restaurants—Hartnell provided glamorous clothes for all this and more!

ABOVE AND ABOVE RIGHT Two evening ensembles were designed for the grand entrance. Hartnell consistently studied paintings and designs of the past, and in the early 1960s, his passion for the eighteenth-century Italian painter Pietro Longhi and other Venetian depictions of fashionable life inspired him to design short-sleeved fur-cuffed floor-sweeping coats to be worn over evening dresses.

OPPOSITE A similar outfit was later developed for inclusion in a series of Nicaraguan postage stamps featuring leading fashion designers.

OVERLEAF After the demise of the crinoline, Hartnell consistently played with the earlier designs of his hero Worth. Reviving the bustle in the 1950s, Hartnell's slim-fitting dresses opened at the back to a full or trailing skirt and were produced into the 1960s. A drawing from the early 1950s, left, indicates a softening of evening formality in the use of pointed revers, a result of his Magpie designs. In the evening dress of contrasting colors and materials, right, a reversed collar forms the back above a complicated draped skirt that emanates from a loosely tied, flowing bow. Hartnell was always aware that clothes are rarely seen head-on and carefully considered every angle.

LEFT AND RIGHT For the Investiture of the Prince of Wales at Caernarvon Castle in North Wales in 1969, Hartnell designed a remarkable ensemble for the Queen. The fashionably short silk dress and fitted coat was complemented by a matching parasol and a modernized embroidered version of a Tudor hat, in keeping with the setting. The Queen Mother, seen with Princess Margaret in the background, wore an apple green ensemble and a feather trimmed hat. This was Hartnell's last contribution to a major State Occasion before the Queen's Silver Jubliee of 1977.

Above all...it was a family affair

By Cyril Aynsley and Tim Heald

in the castle with the Prince

With the world and the Royal family looking on — the Queen presents her son to the people

AFFORDABLE CHIC

Norman Hartnell consistently remained at the top of his profession for six decades by utilizing his unique gifts as a designer to interpret changing fashion. It was no surprise that the royal designer embraced the mood of the 1960s—he had once been the darling of the 1920s. On January 18, 1966, the Reuters news agency reported: "Norman Hartnell, who designs many of Queen Elizabeth II's clothes, bared his models' knees for the first time today when his spring collection was presented. Hartnell, who defended skirts of demure length to the last, could be the opening wedge leading to knee-baring ball gowns and thigh-high daytime tunics from the rest of London's vacillating designers."

Although dressing the Queen maintained his haute couture status, Hartnell was always a modern at heart, instrumental in creating the concept of couture as a conduit to a global fashion brand. In the 1930s he endorsed advertisements for Dolcis shoes, used in his shows. He was among the first couturiers to attach his name to a perfume; his Architecture, Gravure, and Peinture were sold in art moderne bottles that reflected the design of his sensational mirrored salon. Other scents such as White Shoulders and Bright Stars were sold during the war in the United States. After 1934 he made his salon a destination for chic women by means of a lucrative Hat Bar and Fur Grill.

Hartnell was also one of the first great couturiers to understand the potential of prêt-à-porter. What began as patriotic support for Berkertex's Utility-rationed women's clothing during World War II became a huge postwar business that even exported dresses to Paris. Eventually, his name appeared on belts, bags, knitwear, dress and embroidery patterns, cosmetics, nylon stockings, nightwear, menswear, jewelry, sunglasses, and hairspray. There is also his famous In Love perfume, a worldwide success from the 1950s on.

All of these products and the press attention did not guarantee financial success, though. Money flowed into the company and equally swiftly out. A couture house, by necessity, requires a large staff that expects to be paid every week, as well as other overheads. The company was dependent on loans, and by the mid-1960s bankers had possessed one of its assets—Hartnell's country house, Lovel Dene. At the same time, he was mourning the death of his closest friend, whom he had known since Cambridge—the Reverend Richard Blake-Brown, an eccentric priest and author of a series of semi-autobiographical novels. He and Hartnell shared jokes and frequent outings to plays and operas for forty years.

To attract a new clientele, Hartnell opened a ready-to-wear boutique, Le Petit Salon, on the ground floor at Bruton Street. It was designed by the young Kenneth Partridge, who worked with the Beatles. Replicas of the boutique were also built in leading stores throughout Britain. Hartnell even designed one of the most famous mini-dresses of the era—the one that actress Britt Ekland wore to marry Peter Sellers in 1964.

Such was Hartnell's stature that his name appeared in the 1977 New Year's Honours List, when he was appointed Knight Commander of the Royal Victorian Order. This is within the personal gift of the Queen herself and Hartnell became the First Fashion Knight. Prudence Glyn, the well-known fashion journalist, described his career as a new Norman Conquest in the *Times*. Already frail, he died on June 8, 1979. Hartnell left no great fortune, but he did leave an unrivaled fashion legacy. For six decades he imaginatively dressed some of the most distinguished and beautiful women of the twentieth century. His star still shines as the man who created a world fashion center in London.

RIGHT By the 1950s, Hartnell's personal appearances with the new season's collection commanded audiences of thousands. It was an era starved of glamour. At a time when road travel was slow and there were hardly any motorways, the shows were organized as a theatrical company touring England by train from Yorkshire to Scotland to the West Country and the Midlands. The shows not only brought London's chic touch of royalty and society to the women in the provinces, but also promoted the sale of Hartnell branded products.

BY APPOINTMENT
PERFUMERS TO THE LATE KING GEORGE VI
J. & E. ATKINSON LIMITED

By Hartnell is the velours coat with its huge, full-length revers, and the tailored wool dress — that he calls 'Tomboy' — in a narrow diagonal stripe. The blend of the two colours gives the new 'shot' effect, and the leather accessories and the shoes are in red. Lipstick — 'Tomboy' shade — is by Atkinsons of Old Bond Street. Price is 6/11. This lovely shade is the right choice for this season's colours and for countering the cold light of winter. Women who appreciate subtle shades, fine textures, the strong element of vogue, should wear Atkinsons Lipsticks. Like all Atkinsons Cosmetics, they put an individual signature to your good fashion sense.

ATKINSONS COSMETICS

Cleansing Cream 5/3 & 7/9, Toning Lotion 5/6, Tinted Foundation Cream 5/6, Face Powder 5/-, Rouge 3/9, Lipstick 6/11, Hand Lotion 4/6

AC 59-679-120

J. & E. ATKINSON LTD., 24 OLD BOND STREET, LONDON, W.1

LEFT In the early 1950s, the advertising campaign for the Bond Street perfumers Atkinsons featured Hartnell designs with the new cosmetics. The striking reds emphasized the bright spirit engendered by the 1951 Festival of Britain on London's South Bank. At the opening, Queen Elizabeth wore a striking grey Hartnell ensemble featuring geometric openwork panels that echoed the steel girder constructions on display.

OPPOSITE The lavish launch of the In Love scent at the Hartnell salon was accompanied by a song written specially for the occasion by David Heneker, the British lyricist who later wrote *Irma la Douce* and *Charlie Girl*. Blended in Grasse, in the South of France, In Love featured fresh spring flowers, including hyacinths and lilies of the valley, as well as early-summer flowers such as jasmine. At the party, Hartnell house models gave out samples to the guests, and the product range was later developed and successfully marketed to a younger audience.

In the 1950s, Hartnell's country house, Lovel Dene, had a small mink farm attached to it. The farm proved to be a lucrative source of income until the neighbors objected to its smell. Hartnell claimed to be the first designer to have fox dyed in any color and he embellished his more outrageous designs with fur trim whenever possible. A full-time furrier was employed until the late 1960s.

ABOVE LEFT AND ABOVE A loose coat from 1957, and one with the fur worked horizontally that typified the era of the miniskirt in 1968, drawn with the fashionable hats of the season.

OPPOSITE Hartnell frequently used fur as an eye-catching publicity stunt from 1923 onwards. The Snowball Hat took advantage of the promotion around David Lean's British production of the movie *Dr. Zhivago*.

LEFT Hartnell's quick sketches—detailed designs for 1950s dresses and suits—illustrate his inventive skills as he developed a theme. The names of the designs were always a lighthearted feature of his collections, and the thumbnails would be worked up into polished sketches by his talented assistant Ian Thomas, and later sent to the workrooms as patterns.

LEFT BOTTOM The same technique was applied to the design of men's shirts for the American Thomas Shirt Company.

OPPOSITE A 1965 Hartnell suit in slubbed wool and silk was designed for Le Petit Salon, Hartnell's in-house boutique, which sold a wide range of clothing from the workrooms. The garments were finished when a client was fitted. Inevitably, costs spiralled as clients demanded more than the one fitting included in the price. The Petit Salon label went on sale nationwide in replicas of the salon designed for the department stores of the House of Fraser Group.

LEFT The new minimalism of the early 1960s was expressed by Hartnell in a 1962 design for an evening top featuring an embroidered checkerboard black-and-white beaded top highlighted with faux diamonds. The embroidery was done under Miss Edith's careful supervision and the straight black velvet skirt was made in Madame Isabelle's workroom. Hartnell would select the various paillettes, spangles, and stones from his stock of boxes, some dating back to 1923, and push them around with a pencil on his desk until he had the design he sought. Turned into a tracing, the design would then be transferred to the fabric.

OPPOSITE A short dark brown silk evening dress of the late 1960s has a bodice encrusted with white beads and fake diamonds from a stock previously used for many grand dresses of the past, including some made for Hartnell's royal clients.

LEFT AND OPPOSITE From the mid-1950s, Hartnell launched the jewelry for each season with parties in the salon. Models appeared in specially designed dresses, often worn with hats and long gloves, sprinkled with the latest costume jewelry. While many of the designs came from a company in Holland, Hartnell designed some of the pieces. The quality was consistently good and reflects the innovative and lighthearted design of the day.

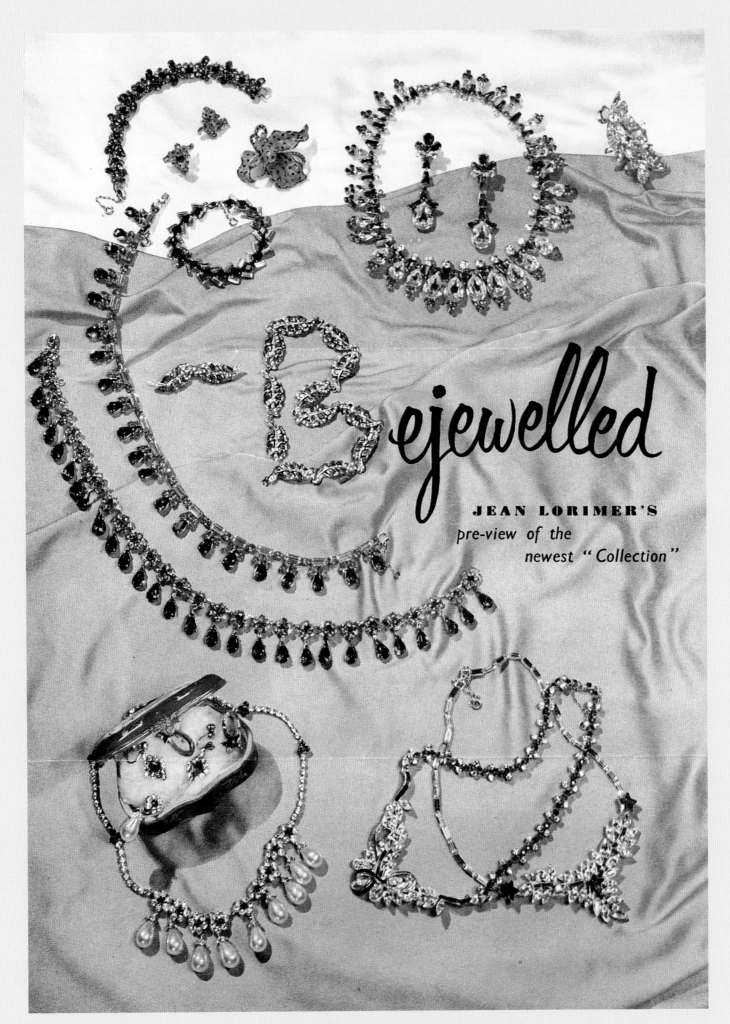

Bejewelled

JEAN LORIMER'S
pre-view of the
newest "Collection"

No 7

Navy/white

LEFT Hartnell considered women's elbows and knees best left unseen, so the miniskirt held little appeal for him as a concept. Yet he produced some interesting examples, such as the carefully detailed jacket and dress for Princess Anne in 1969, worn with either a Stetson or a kerchief.

OPPOSITE A white silk dress with extra-fine seaming and embroidery, subtly highlighted by a beautifully proportioned flat bow, sums up the essence of the best of Hartnell couture of the late 1960s.

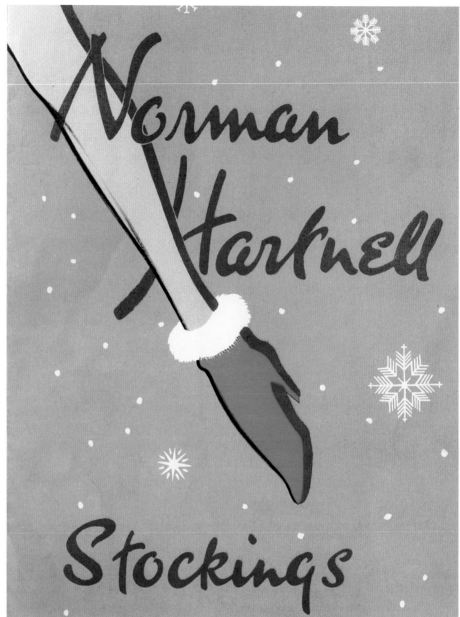

ABOVE Constantly striving to create necessary extra income, the merchandizing of the Hartnell name made headlines with a *Picture Post* cover of 1957 promoting the latest craze for baby-doll nightgowns in nylon, a material then considered exciting because of its drip-dry, noncreasing properties.

ABOVE Nylon stockings were also produced under the Hartnell name. The blonde movie star Shirley Eaton, later famous for her gilded body in the James Bond film *Goldfinger*, promoted the product. Hartnell also designed the amusing Christmas packaging.

ABOVE Although Hartnell always took pride in using the best natural fibers, he also utilized the latest newsworthy artificial textiles with skill. In the 1950s, Ardil, a now-forgotten ICI product, was woven in a silk mill and elaborately embroidered in-house. Raine, Countess Spencer, the former Mrs. Gerald Legge, wore an identical dress at the coming-out dance for Frances Sweeny, the daughter of the Duchess of Argyll (the former Mrs. Charles Sweeny), at Claridge's hotel in 1955.

ABOVE Keeping the Hartnell name chic without devaluing its allure could be challenging. These dress patterns were elegant enough to promote the name and give a touch of glamour to the early 1960s, a time when making elaborate dresses at home was a widespread activity in Britain.

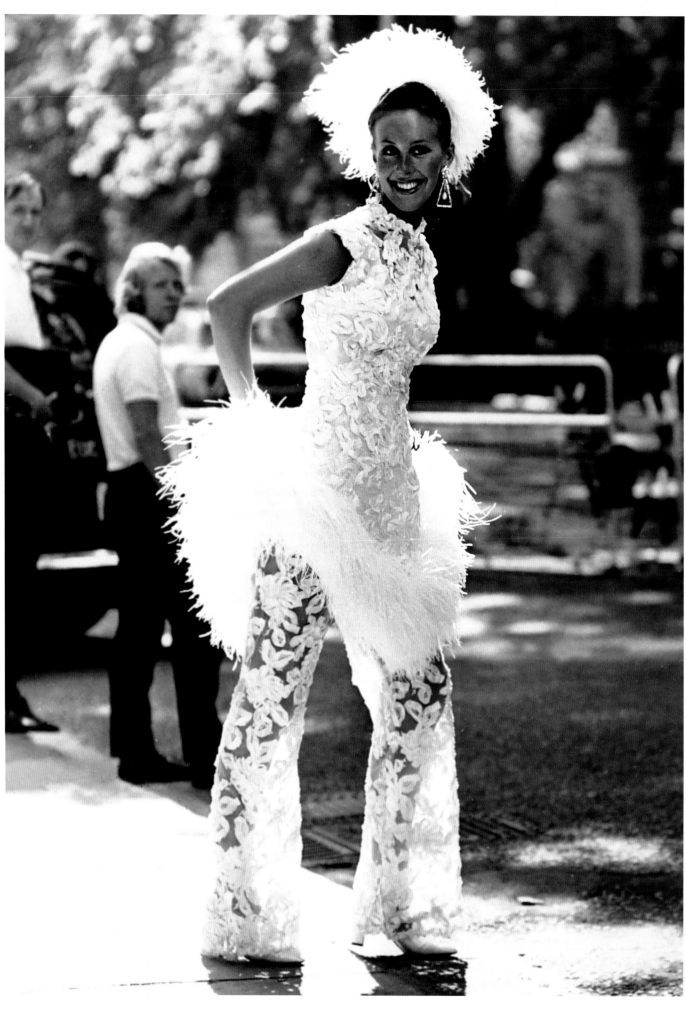

LEFT Novelty designs were always in demand. This 1968 outfit is part of a special collection in which designs from the mid-1920s were reworked to great effect. Cool lace pants and a feathered top were crowned with a matching hat—as Hartnell turns street fashion into a dashing couture statement.

OPPOSITE New materials and ideas are combined in a pair of transparent plastic evening booties with stiletto heels and unusual fastenings at the back, making them part of the early 1960s Space Age when set against the beer pump handles of a pub countertop.

SWAN SONG

Norman Hartnell was imbued with a feeling for music. As a child he joined his family around the piano to sing the current songs, and as a teenager during World War I, he frequented the musical shows in the West End of London. Above all, he loved to sing. He sang at the Mill Hill School and at Cambridge University. He sang at home while he designed and listened to the radio and records. Later, he was often seen in the audience at various musicals. He also created costumes for many well-known actresses of stage and screen.

But even his royal patronage could not avert a financial crisis at the House of Hartnell in the mid-1960s. For various reasons, Lovel Dene had been transferred into the company name, and the company bank claimed it as part of its debt. Hartnell was devastated. His one safe haven and source of so much inspiration was lost to him. After forty years in business he had few material possessions and never found another house he liked.

Eventually, he bought part of a large converted house at Ascot and threw himself into his work, spending more time in London. His life resembled the early days in the 1920s, when he lived in Mayfair, but he now inhabited

rooms above the salon on Bruton Street. His health had suffered and, although his clients remained loyal to him and his talents did not fail, he became frail and suffered a fatal heart attack in 1979.

Before his death, he was rejuvenated for a time by the recognition of his talent and service in the New Years Honours List of 1977, with his appointment as a Knight Commander of the Royal Victorian Order (KCVO). There was a further delight in store for him. When he arrived at Buckingham Palace for his investiture, he found Queen Elizabeth the Queen Mother present to bestow the honor, a surprise arranged specially for him by his sovereign, Queen Elizabeth II.

RIGHT Hartnell is seen at the keyboard of his white grand piano placed in the bay window of the drawing room at Lovel Dene. He epitomized the idea of sophistication from the 1930s to the 1950s. The room was carpeted in a color he devised—Vaseline Yellow—the perfect background for Regency and modern furniture. The signed royal photographs show some of his favorite clients wearing his designs.

ABOVE Lovel Dene was photographed for a magazine in the Coronation summer of 1953. Hartnell's new Jaguar is parked outside the drawing room window—a symbol of his prosperity. The house in Windsor Forest was the designer's refuge. Bought in the early 1930s, it was modernized by Gerald Lacoste, the architect of the moderne interiors at 26 Bruton Street. An oasis of tranquility where Hartnell could design undisturbed, the house was continually refurbished to his ideas, becoming Regency Gothic in style.

LEFT Shortly before it was sold in the mid-1960s, Lovel Dene was photographed after the terrace had been treated in an elaborate Italianate manner to complement the 1935 neo-classical Lacoste pavilion at the end of the long lawn.

RIGHT In the 1930s, mirrored doors to the study and elaborate pelmets were added to the Regency dining room with its festive red and off-white color scheme and antique mahogany furniture.

The Cathedral and Collegiate Church
of St. Saviour and St. Mary Overie,
Southwark

A MEMORIAL SERVICE

for

NORMAN HARTNELL

12th June 1901 – 8th June 1979

MONDAY, 25th JUNE 1979

at 12 noon

BIBLIOGRAPHY

"Abbey Arrival: The Steps to a New Elizabethan Age." *Picture Post*, June 13, 1953, 48, 50.

"Adel models Hartnell's nighties." *Picture Post*, March 18, 1957.

"Always that warm smile... always that queenly style." *The Evening Standard*, August 4, 1970, 18.

Amies, Hardy. *Just So Far*. London: Collins, 1954.

——. *Still Here*. London: Weidenfeld & Nicolson, 1984.

"New Showroom in Bruton Street, W.I., For Messrs. Hartnell, Ltd." *Architecture Illustrated*, December 1934, 179–184.

Argyll, Margaret Duchess of. *Forget Not*. London: W.H. Allen, 1975.

Baily, Leslie. *Scrapbook for the Twenties*. London: Muller, 1959.

Balmain, Pierre. *My Years and Seasons*. London: Cassel, 1964.

Barrow, Andrew. *Gossip: A History of High Society from 1920 to 1970*. London: Hamish Hamilton, 1978.

Batchelor, Vivien. *Her Most Gracious Majesty, Queen Elizabeth II, Vol. I: 1926 to 1952*. London: Pitkins, 1952.

Beaton, Cecil. *The Best of Beaton*. London: Weidenfeld & Nicolson, 1973.

——. *The Glass of Fashion*. London: Weidenfeld & Nicolson, 1954.

——. *Photobiography*. London: Odhams, 1951.

——. *Royal Portraits*. London: Wiedenfeld & Nicolson, 1963.

——. *Scrapbook*. London: Batsford, 1938.

——. *The Wandering Years: Diaries: 1922–39*. London: Weidenfeld & Nicolson, 1961.

——. *The Years Between: Diaries: 1939–44*. London: Weidenfeld & Nicolson, 1965.

——. *The Strenuous Years: Diaries: 1948–55*. London: Weidenfeld & Nicolson, 1973.

Beaton, Cecil and Peter Quennell. *Time Exposure*. London: Batsford, 1941.

Beckles, Gordon. *The Coronation Souvenir Book*. London: Daily Express, 1937.

"A birthday album of photographs." *Evening Standard*, August 4, 1970: 18.

Bolitha, Hectgor, C.F.J. Hankinson, A.L. Rowse, Malcolm Thomson, Sir Thomas White, and the Bishop of Bath and Wells. *The Coronation Book of Queen Elizabeth II*. London: Odhams, 1953.

Bowles, Hamish. *Jacqueline Kennedy: The White House Years: Selections from the John F. Kennedy Library and Museum*. New York: Bulfinch Press, 2001.

Bradford, Sarah. *Elizabeth: A Biography of Her Majesty the Queen*. London: Heinemann, 1996.

"British Look, The." *Time*, December 10, 1951.

"Carleton Varney on The Westbury's Hartnell Suite." *Architectural Digest*, January 2003, 138.

Carter, Ernestine. *The Changing World of Fashion*. London: Weidenfeld & Nicolson, 1977.

Cartland, Barbara. *Scrapbook*. Great Britain: Royal Photographic Society, 1980.

——. *We Danced All Night*. London: Hutchinson, 1971.

Cassini, Oleg. *In My Own Fashion: An Autobiography*. Riverside, NJ: Simon & Schuster, 1987.

Channon, Henry. *'Chips': The Diaries of Sir Henry Channon*. London: Weidenfeld & Nicolson, 1967.

Chase, Edna Woolman and Ilka Chase. *Always in Vogue*. London: Victor Gollancz, 1954.

Cochran, Charles B. *Cock-a-Doodle-Do*. London: Dent, 1941.

"Colobium sindonis." Description of British coronation ceremony clothing. Wikipedia. 16 July 2007 ‹http://en.wikipedia.org/wiki/Colobium_sindonis›

"Coronation Couturier." *Picture Post*, January 24, 1953, 19, 22.

"Coronation Parade for the Queen." *Illustrated*, December 6, 1952, 28–29.

Creed, Charles. *Maid to Measure*. London: Jarrolds, 1961.

The Daily Express. Thursday, November 21, 1927.

De Courcy, Anne. *1939: The Last Season*. London: Phoenix, 2003.

De la Haye, Amy, Ed. *The Cutting Edge: Fifty Years of British Fashion, 1947–1997*. London: Victoria & Albert Museum, 1996.

De la Haye, Amy and Shelley Tobin. *Chanel: The Couturiere at Work*. London: Victoria & Albert Museum, 1995.

Derrick, Robin and Robin Muir, Eds. *Unseen Vogue: The Secret History of Fashion Photography*. London: Little Brown & Company, 2002.

Desmond, Florence. *Florence Desmond by Herself*. London: George Harrap, 1953.

Dior, Christian. *Dior by Dior: The Autobiography of Christian Dior*. London: Weidenfeld & Nicolson, 1957.

"Dressing as a 'Queenly' Queen." *Daily Telegraph and Morning Post*, February 23, 1961, 13.

Duff, David. *George and Elizabeth*. London: Collins, 1983.

Edwards, Anne. *Royal Sisters: Elizabeth and Margaret: 1926–1956*. London: Collins, 1990.

Edwards, Anne and Robb. *The Queen's Clothes*. London: Daily Express, 1977.

Edwards, Arthur and Charles Rae. *The "Sun": The Queen Mum - Her First Hundred Years*. London: HarperCollins, 2000.

"Elizabeth's Gown Set with Pearls." *New York Times*, November 20, 1947, 13.

Ellis, Jennifer. *The Duchess of Kent: An Intimate Portrait*. London: Odhams, 1952.

"An Enduring Beauty." *The Scotsman*, February 11, 2002.

Field, Leslie. *The Queen's Jewels: The Personal Collection of Elizabeth II*. London: Weidenfeld & Nicolson, 1987.

Flanner, Janet. *London was Yesterday 1934–1939*. London: Michael Joseph, 1973.

Garland, Madge. *The Indecisive Decade*. London: Macdonald, 1968.

——. *Fashion: A Picture Guide to Its Creators and Creations*. Harmondsworth, UK: Penguin, 1962.

Gibson, Robin and Pam Roberts. *Madame Yevonde: Colour, Fantasy, and Myth*. London: NPG, 1990.

Giroud, Francoise. *Dior: Christian Dior 1905–1957*. London: Thames and Hudson, 1987.

Gladwyn, Cynthia. *The Diaries of Cynthia Gladwyn*. London: Constable, 1995.

Gloucester, Princess Alice, Duchess of. *Memories of Ninety Years*. London: Collins & Brown, 1991.

Glynn, Prudence. *In Fashion: Dress in the Twentieth Century*. London: George Allen and Unwin, 1978.

Graves, Charles. *The Cochran Story: A Biography of Sir Charles Blake Cochran*. London: W.H. Allen, c. 1952.

"Hartnell and the Coronation." *Picture Post*, January 24, 1953.

"Hartnell Bares the Knee." *New York Times*, January 19, 1966, 36.

Hartnell, Norman. *Royal Courts of Fashion*. London: Cassell, 1971.

——. *Silver and Gold*. London: Evans Brothers, 1955.

——. *Silver and Gold*. New York: Pitman, 1956.

"Hartnell's India wardrobe for the Queen." *Daily Express*, February 1, 1961.

Ideal Home, November 1947, cover, 28.

Illustrated, August 25, 1951, 22–23.

Keay, Douglas. *Queen Elizabeth the Queen Mother*. London: IPC, 1980.

Keenan, Brigid. *The Women We Wanted to Look Like*. London: Macmillan, 1977.

King George's Jubilee Trust. *Their Majesties' Visit to Canada, The United States of America, and Newfoundland*. London: Macmillan, 1939.

King George's Jubilee Trust. *The Royal Family in Wartime*. London: Odhams, 1945.

Lambert, Angela. *1939: The Last Season of Peace*. London: Weidenfeld & Nicolson, 1989.

Langmead, Jeremy. "Her Majesty Isn't Naff, She's Avant-Garde." *The Observer*, November 23, 2003.

Laver, James. *Clothes*. London: Burke, 1952.

——. *Women's Dress in the Jazz Age*. Great Britain: Hamish Hamilton, 1964.

Laye, Evelyn. *Boo To My Friends*. London: Hurst & Blackett, 1958.

Levin, Phyllis Lee. "Astor Ballroom Is Scene of Regal English Show." *New York Times*, April 21, 1960, 26.

MacCarthy, Fiona. *Last Curtsey: The End of the Debutantes*. London: Faber & Faber, 2006.

Martin, Stephen. "Princess Margaret: August 21, 1930 – February 9, 2002." *Sunday Mirror*, February 10, 2002.

"Marquis's Son Weds." *The Daily Mirror*, October 28, 1927.

Massingbird, Hugh. *Her Majesty Queen Elizabeth the Queen Mother, Woman of the Century*. London: Macmillan, 1999.

Matthews, Herbert L. "Pomp Marks Event: Grandeur and Tradition Hold Sway with World's Royalty Attending." *New York Times*, November 21, 1947, 1–2.

McConathy, Dale and Diana Vreeland. *Hollywood Costume: Glamour! Glitter! Romance!* New York: Abrams, 1976.

McDowell, Colin. *A Hundred Years of Royal Style*. London: Muller Blond and White, 1985.

Menkes, Suzy. *The Royal Jewels*. London: Grafton, 1985.

Montague-Smith, Patrick. *The Royal Family Pop-Up Book*. London: Deans International Publishing, 1984.

Morrah, Dermot. *The Royal Family*. London: Odhams, 1950.

——. *The Royal Family in Africa*. London: Hutchinson and Co., 1947.

Morris, Bernadine. "Sir Norman Hartnell Dead at 78; Dressmaker for Queen Elizabeth." *New York Times*, June 9, 1979, A11.

Mulvagh, Jane. *Costume Jewellry in Vogue*. London: Thames & Hudson, 1988.

Munn, Geoffrey. *Tiaras: A History of Splendor*. London: Antique Collectors' Club, 2002.

Nichols, Beverley. *Oxford-London-Hollywood: An Omnibus containing: Twenty-Five, Are They the Same at Home?, and The Star-Spangled Manner*. London: Cape, 1931.

——. *The Sweet and Twenties*. London: Weidenfeld & Nicolson, 1958.

Nickolls, L.A. *The First Family: A Diary of the First Year*. London: MacDonald, 1950.

——. *Royal Cavalcade: A Diary of the Royal Year*. London: MacDonald, 1949.

——. *The Royal Story: A Diary of the Royal Year.* London: MacDonald, 1951.

Norwich, John Julius. *Sovereign: A Celebration of Forty Years of Service.* North Pomfret, VT: Trafalgar Square, 1992.

"Notes on People." *New York Times*, December 31, 1976, 34.

"Pageantry of the Coronation." *Illustrated*, November 29, 1952.

Paris Match, Saturday February 2, 1956, cover.

Peacocke, Marguerite D. *Queen Mary: Her Life and Times.* London: Odhams, 1953.

Pepper, Terence. *Dorothy Wilding: The Pursuit of Perfection.* London: National Portrait Gallery Publications, 1991.

Pick, Michael. "Gerald Lacoste." *Journal of the Thirties Society*, 1982.

——. "The Queen's Coronation Dress." *Daily Mail: YOU*, 2002.

—— "Royal Design, Loyal Style." *London Collections*, 1977.

Pointe De Vue, September 21, 1956, cover.

Pope, Virginia. "Court Dressmaker Shows Gowns Here." *New York Times*, October 31, 1953, 20.

Pope-Hennesey, James. *Queen Mary: 1867–1953.* London: George Allen & Unwin, 1959.

"Princess Margaret Latest Portrait." *The Australian Women's Weekly.* October 28, 1952.

Pringle, Margaret. *Dance Little Ladies: The Days of the Debutante.* London: Orbis, 1977.

"Property from the Collection of Her Royal Highness The Princess Margaret, Countess of Snowdon. Vol. I: Jewelery and Fabergé." *Christie's.* London: June 13, 2006, 132, 148, 181.

"Property from the Collection of Her Royal Highness The Princess Margaret, Countess of Snowden. Vol. II: Silver, Furniture, and Works of Art." *Christie's.* London: June 14, 2006, 2, 23, 62, 66–67, 71, 77, 98, 123–124, 149, 156–157.

Quant, Mary. *Quant by Quant.* London: Cassell, 1966.

"The Queen's Dressmaker." *Picture Post*, November 19, 1938, 26.

"A Queen's Version of the Crinoline Gown." *Women's Wear Daily*, August 5, 1938.

"The Queen's Washington WOW!" *Daily Mirror*, October 19, 1953, 13.

Recorder, The. January 27, 1951.

Robb. *Lifestyle.* London: Elm Tree, 1979.

Robinson, Julian. *Fashion in the Forties.* London: Academy, 1976.

Robyns, Gwen. *Barbara Cartland: An Authorised Biography.* London: Sidgwick & Jackson, 1984.

Ross, Josephine. *Society in Vogue.* London: Conde Nast Books, 1992.

"Round of Festivities Keeps King and Queen Busy from Laying Wreath at Tomb of Unknown Soldier in Morning to Opera Gala Lasting Past Midnight." *New York Herald Tribune*, Paris, July 21, 1938.

"Royal Dresses." *The Evening Standard*, July 22, 1938.

Saville, Margaret. *Royal Sisters: Vol. I.* London: Pitkins, 1949.

——. *Royal Sisters: Vol. II.* London: Pitkins, 1950.

Schiaparelli, Elsa. *Shocking Life: The Autobiography of Elsa Schiaparelli.* London: Dent, 1954.

Sheridan, Lisa. *From Cabbages to Kings.* London: Odhams, 1955.

——. *Our Princesses in 1942.* London: John Murray, 1942.

——. *Princess Elizabeth at Home.* London: John Murray, 1944.

Shew, Betty Spencer. *Queen Elizabeth the Queen Mother.* London: Hodder & Stoughton, 1954.

——. *Royal Wedding.* London: MacDonald, 1947.

Smith, Sydney. "The Dress of the Year." *The Daily Express*, April 9, 1957.

Snagge, John. *Princess Margaret: A Pictorial Record of Her Life and Wedding.* London: Odhams, 1960.

Strong, Roy. *Cecil Beaton: The Royal Portraits.* London: Thames and Hudson, 1998.

Talbot, Godfrey. *Queen Elizabeth the Queen Mother.* London: Country Life Books, 1978.

——. *The Royal Family.* Surrey, UK: Country Life Books, 1980.

Talbot, Godrey and Wynford Vaughan Thomas. *Royalty Annual No. 3.* London: Andrew Dakers, 1954.

Thaarup, Aage. *Heads and Tales.* London: Cassell, 1956.

Thomas, Wynford Vaughan. *Royal Tour: 1953–4.* London: Hutchinson, 1954.

Vickers, Hugo. *Cecil Beaton: The Authorised Biography.* London: Weidenfeld & Nicolson, 1985.

Walsh, John. "My Dear, We Always Partied Like It Was 1999." *The Independent*, December 16, 1999.

Weinraub, Judith. "They Make Their Clothes Fit for Their Queen." *New York Times*, July 4, 1976, 36.

Wheeler-Bennett, John. *King George VI: His Life and Reign.* London: Macmillan, 1958.

Wilcox, Claire and Valerie Mendes. *Modern Fashion in Detail.* London: Victoria & Albert Museum, 1991.

Winn, Godfrey. *The Young Queen: The Life Story of Her Majesty Queen Elizabeth II.* London: Hutchinson, 1952.

Wulff, Louis. *Elizabeth and Philip: Our Heiress and Her Consort.* London: Sampson Low, 1947.

——. *Her Majesty Queen Mary: An Authoritative Portrait of a Great Lady in Her Years as Queen Mother.* London: Sampson Low, 1949.

——. *Queen of Tomorrow.* London: Sampson Low, 1947.

Young, Sheila. *The Queen's Jewelery.* London: Ebury Press, 1969.

This book is dedicated to the memory of my mother Helene, and also to the memory of the late Ian Thomas, both of whom separately encouraged me to record the life and times of Sir Norman Hartnell.

I am deeply indebted to:

Her Majesty Queen Elizabeth II, for her gracious consent to reproduce certain key images in this book;

Her Late Majesty Queen Elizabeth the Queen Mother, for selecting a wide range of her historic Hartnell dresses and allowing the author to view and photograph them at Clarence House;

Her Late Royal Highness Princess Margaret, Countess of Snowdon, for memories of Hartnell and his influence;

Her Late Royal Highness Princess Alice, Duchess of Gloucester, for providing extensive information on her patronage of Hartnell;

Her Royal Highness Princess Michael of Kent for so graciously offering to write the foreword and highlighting the role in fashion history of her mother-in-law, Her Late Royal Highness Princess Marina, Duchess of Kent.

For information and assistance directly related to this book I wish to acknowledge with grateful thanks the influence of the late Mr. Gerald Lacoste, a friend of Hartnell's and brilliant architect of the Hartnell art moderne salon at 26 Bruton Street and of Lovel Dene in Windsor Forest. It was in one of the houses Lacoste designed that my parents first met in 1938, and where he suggested that I record Hartnell's life. My late mother, a 1930s Hartnell client, first enthused me with her memories of her clothes and life in London between the wars. The late Mr. Ian Thomas, then the third Dressmaker by Appointment to HM the Queen, kindly informed me in great detail of his days as Sir Norman's assistant and wrote pages of notes for me. Mr. Kenneth Partridge, the interior designer of the Hartnell Petit Salons and of various glamorous dress shows, added a multitude of memories and invaluable contacts. Mr. and Mrs. Emanuel Silverman and Mr. Roy Dixon, owners of the last full-scale incarnation of the House of Hartnell, commissioned me to completely renovate the building and encouraged my researches. Mrs. Caroline Knox, at that time with John Murray, originally commissioned a biography. Mr. Eiji

Takahatake has loyally supported me and the project with great determination and constant encouragement from the beginning, as has the Reverend Julian Browning, son of the publisher at Evans Brothers of Hartnell's autobiography *Silver & Gold*.

The full biography of Hartnell intended to follow this book will acknowledge the many people and institutions who have so readily assisted me with my part-time researches over the last fifteen years, during which many of my informants have sadly died.

I am further particularly indebted to:

The late Sir Hardy Amies; Mr. Geoffrey Angold; Mr. Murray Arbeid; the late Margaret, Duchess of Argyll; Miss Diane Banks; Mr Hugo Bourcier; Mr. Nigel Brunning; the late Dame Barbara Cartland; Mr. John Cavanagh; the late Lady Diana Cooper; Miss Hannerle Dehn (Mrs. Robin Sligh); the late Mr. Richard Dunn, Ms Edwina Ehrman of The Museum of London; Miss Evelyn; Ms Leslie Field; the late Mrs Daphne Fielding; the late Mr. Kenneth Fleetwood; Mr. Freddie Fox; Miss Julie Harris; Ms Amy de la Haye; Mr. Clifford Henderson; the late Mr. David Hicks; Mr. Bevis Hillier; the late Caroline, Lady Hobart; Miss Camilla Hornby; Sir Robin Janvrin; Mr. Timothy Jones; the late Mrs. Eleanor Lambert; the late Miss Evelyn Laye; Mr. Mark Law; the late Raffaele, Duchess of Leinster; Miss Louie; Mr. Robert Luck; Ms Joanna Maschner; the late Mr. Desmond Morris; the late Dame Jean Maxwell Scott; Mr. Geoffrey Munn; Mrs. Brenda Naylor; the late Mr. Robert Nesbitt; Mr. and Mrs. John Partridge; the late Mr. Ronald Paterson; Mr. Simon Powell-Jones; Mr. Alan Powers; Jane, Lady Rayne; the late Anne, Countess of Rosse; Mr. Percy Savage; Mrs. Prudence Seddon; the late Mr. Michael Sherard; Professor Dr. Gavin Stamp; Mr. William Tallon; Mr. Gnyuki Torimaru (Yuki); Mr. Hugo Vickers; the late Mrs. Diana Vreeland; the late Mr. Norris Wakefield; Professor Dr. David Watkin; the late Mr. Michael Whittaker; Ms Karen Lawson and Ms Shuriti Patel from the Royal Collection Picture Library.

I also acknowledge with gratitude my extraordinary publisher Suzanne Slesin and managing editor Jane Creech of Pointed Leaf Press for their belief in our shared vision of this book and our remarkable designer Stafford Cliff, ably assisted by the talents of Ian Hammond, photographer, Kulbir Thandi, and fashion stylist, Kim Edwards in London; and Dominick Santise, Jr. as well as the others of the New York office including Chris Cameron, Debra Castellano, Cynthia Crippen, Katherine Murphy, Christine Owen, Dan Shaw, and Anne Hellman White.

Pointed Leaf Press would like to thank Jessica Almonte, Matthew Bailey, Marko Barlovic, Hamish Bowles, Nicky Burden, S. Victor Burgos, Robert Chong, Phyllis Collazo, Caroline Corbeau, Diane Courtney, Brett Croft, Mark Eastment, John Espinosa, David Friedlander, Cynthia Goodwin, Roberta T. Groves, Kate Hald, Rosemary Harden, Alison Hart, John Hustler, Danny Howell, Christophe Juin, Joan Kron, Mel Knight, Chi-Keat Man, Efi Mandrides, Chris McVoy, Diane Meuser, Derek, Jessy, and Jonah Miller, Louise Morgan, Leigh Montville, Robin Muir, Beth O'Neill, Anna Pearce, Sarah Phillips, Katherine Rogerson, Denis Ross, Joanna and Anastasia Santise, John Scott, Max Sinsteden, Liz Smith, Molly Sorkin, Michael Steinberg, Mark Swift, Sarah Williams, Vince Hamilton and Hung Chu at Toppan, Carleton Varney and Brinsley Matthews of Dorothy Draper & Co. Inc., New York and London.

BELOW LEFT A sketch of Le Petit Salon which was on the ground floor of the House of Hartnell.

FRONT JACKET The beaded top of a mid-1960s short evening dress by Hartnell epitomizes haute couture craftsmanship and expresses forty years of the luxurious art of superb in-house embroidery.

BACK JACKET Hartnell, who for six decades designed for the world's most glamourous women, including HM Queen Elizabeth II and all the ladies of the British Royal Family, was photographed leaving his London salon in 1938, left. The Queen, right, wore one of his sparkling gowns to a dinner in her honor in New York City in 1957.

COVER An official Blue Plaque sanctioned by English Hertitage to denote the residences of important contributors to British life and history is affixed to the facade of 26 Bruton Street, Mayfair. Hartnell worked and lived there from 1934 to 1979.

PAGES 264–265 For about three decades, Hartnell designed Christmas cards which were made in the embroidery workroom from the beads used in the his dresses.

PAGES 266–267 The House of Hartnell had labels spanning sixty years from ready-to-wear to haute couture.

BACK ENDPAGE A detail of the Coronation dress of Queen Elizabeth II shows the Scottish thistle, which is one of the emblems of the United Kingdom.

©2007 Michael Pick

First edition
10 9 8 7 6 5 4 3 2 1
Library of Congress control number: 2007934591
ISBN-10: 0-9777875-3-2
ISBN-13: 978-0-9777875-3-2